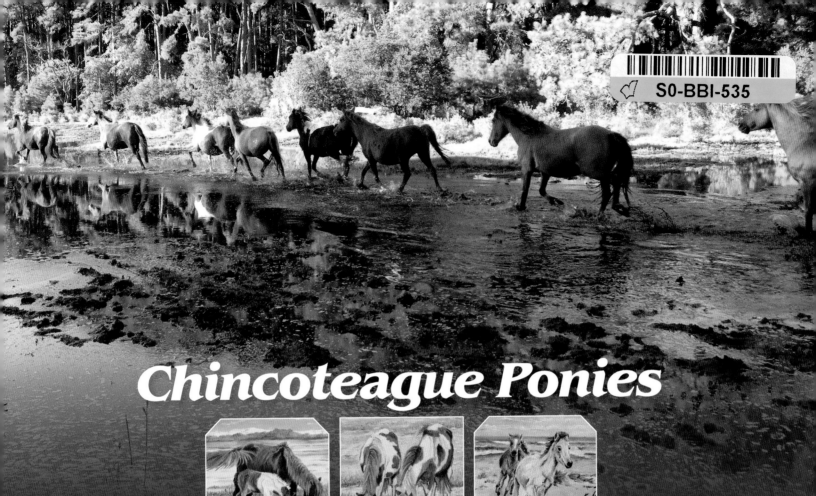

Chincoteague Ponies

Untold Tails

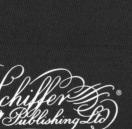

Schiffer Publishing Ltd®

4880 Lower Valley Road • Atglen, PA 19310

Printed in China

Lois Szymanski *with* Pam Emge
Photography by Linda Kantjas

Other Schiffer Books by the Authors:
Wild Colt, 978-0-7643-3975-2, $16.99
Out of the Sea: Today's Chincoteague Pony, 978-0-87033-595-2, $14.95
The True Story of Sea Feather, 978-0-7643-3609-6, $14.99
Grandfather's Secret, 978-0-7643-3535-8, $12.99

Other Schiffer Books on Related Subjects:
Chincoteague Island, 978-0-7643-2919-7, $29.99
The Assateague Ponies, 978-0-87033-330-9, $8.75

Designed by Danielle D. Farmer
Cover Design by Bruce M. Waters
Type set in ITC Benguiat Std

ISBN: 978-0-7643-4085-7
Printed in China

Schiffer Books are available at special discounts for bulk purchases for sales promotions or premiums. Special editions, including personalized covers, corporate imprints, and excerpts can be created in large quantities for special needs. For more information contact the publisher:

Published by Schiffer Publishing Ltd.
4880 Lower Valley Road
Atglen, PA 19310
Phone: (610) 593-1777; Fax: (610) 593-2002
E-mail: Info@schifferbooks.com

For the largest selection of fine reference books on this and related subjects, please visit our website at: **www.schifferbooks.com**
We are always looking for people to write books on new and related subjects. If you have an idea for a book, please contact us at **proposals@schifferbooks.com**

This book may be purchased from the publisher.
Please try your bookstore first.
You may write for a free catalog.

In Europe, Schiffer books are distributed by
Bushwood Books
6 Marksbury Ave.
Kew Gardens
Surrey TW9 4JF England
Phone: 44 (0) 20 8392 8585; Fax: 44 (0) 20 8392 9876
E-mail: info@bushwoodbooks.co.uk
Website: www.bushwoodbooks.co.uk

Dedication

To my husband, Dan who has lived with my Chincoteague Pony obsession for over 30 years

– Lois Szymanski

To my friend, Pat Chrysler who spent many hours patiently waiting for me while I patiently waited for just the right moments to take pictures of the ponies.

– Linda Kantjas

To my partner, Jack, and to Linda and Lois for helping to turn this dream into reality.

– Pam Emge

Acknowledgments

The authors and the photographer/illustrator would like to acknowledge the following people for openly sharing photos, resources, information, photo identification, and stories. Your assistance was invaluable; without you this book identifying ponies and telling their stories would not have come to fruition.

Jean Bonde, the Buyback Babes, Sarah Boudreau, the Chincoteague Volunteer Fire Department, Jeff Clark, Lara Cornell, Deborah Elliott Fisk, the Feather Fund, Carol Gazunis, Arthur Leonard, Sue Lowery, Kelly Lidard, Karen Peck, Robin Pool, Joanne Rome, Liz Spino, Roe Terry, Allison Turner, and Debbie Folsom.

Introduction

Much has been written about the wild ponies of Chincoteague Island, but to those who visit the island there's more to the Chincoteague Ponies than simple statistics and facts. Each pony is an individual with a name and story of their own. Their history and heritage is deep and well-rooted and the wetland environment in which they live offers unique challenges for survival.

The Native American word "Chincoteague" (pronounced SHIN-co-teeg) means "beautiful land across the waters" and the ponies connected to the island are a popular piece of the beauty puzzle. Through photos and artwork, we embark on a mission to share with you the history of the ponies we know and love and the stories that make them special.

Visitors are sometimes confused when they learn that Chincoteague Ponies do not live on Chincoteague Island. They live across a channel of the bay on Assateague Island, a barrier island that protects Chincoteague Island, which lies below sea level.

Assateague Island is not inhabited by humans, but is a sanctuary for waterfowl, songbirds, reptiles, and many other animals. The 48,000-acre, 37-mile-long island is split by state lines. The Maryland side is governed by the National Park Service. Their pony herds are known as Assateague Ponies. The Chincoteague Fire Company owns the pony herds on the Virginia side of the island. The land on the Virginia side is controlled by the Chincoteague National Wildlife Refuge, but the ponies are managed by a pony committee within the fire department. A fence separates the ponies on either side.

Many refer to the ponies on Chincoteague in two groups: the northern herd and the southern herd. The true definition of herd is, "A number of wild animals of one species that remain together as a group." The southern and northern groups do not stay together in one group on each side of the island. They split into bands with a single stallion governing each group of mares. For this reason, within this book we refer to each grouping of a stallion and his mares as a herd. Therefore, we have the northern herds and the southern herds.

Chincoteague Ponies live in a harsh environment with sweeping ocean winds and hordes of biting insects and mosquitoes the size of golf balls. The marsh cord grass that is their main meal is low on nutrition and high on salt.

However, the Chincoteague Ponies have a fan base all their own. Followers visit regularly and keep close tabs on the ponies. They are aware of herd designation, location of water holes and vernal pools, and which animals coexist with the ponies. They watch for injured or missing ponies, flooding, coastal storms, and other problems the ponies face and report their concerns to the Chincoteague Volunteer Fire Company.

There is much debate over how the ponies arrived on Assateague. The most popular theory is that Spanish Barb horses swam ashore from a sinking Spanish galleon called the *La Galga* in 1750. They adapted to the island's living conditions, but became more diminutive through years of poor nutrition. Others believe they were placed on the island to avoid taxation in the 1800s when the dollar amount paid to the government was based on head of livestock owned. There is even a theory that pirates unloaded the ponies, intending to come back. The shipwreck theory gained credence several years ago when a Spanish galleon was unearthed on Assateague Island in an area that would have been ocean hundreds of years ago.

The Chincoteague Ponies differ from the Assateague Ponies on the Maryland side in subtle ways. Ponies on the Maryland side stand 12 to 13 hands. Chincoteague Ponies may reach 14.2 hands and often have more refined heads. This is due to the influx of outside breeds over the years.

Over time, the fire department worried about inbreeding on the island. To keep the gene pool from becoming stagnant, they purchased 20 mustangs from the Bureau of Land Management in 1939 and set them free on the island. However, the wetland conditions on Assateague Island are the polar opposite of the desert conditions that the Mustangs knew and only a handful survived. Those that did influenced the breed's size.

Many years later a Florida breeder named Stanley White donated an Arabian stallion named Premier. At first, worrying about the safety of the stallion, the mares were brought from Assateague Island to the Chincoteague Pony Farm owned by Donald Leonard to breed to Premiere. The following year he was released on the island. He soon disappeared. No one knows what happened to Premiere. Arthur Leonard, son of Donald Leonard, believes he was stolen. "He was a

magnificent animal," he said. Premiere may have vanished, but his genes live on and can be seen often in ponies with refined Arab heads, tinier noses, and arching necks.

Leonard said that other breeds were added intermittently over the years: a Shetland pony at one time, a couple of quarter horses in the late sixties, and close to 50 mustangs again in the seventies. Once again, the Mustangs did not fare well. The last outside influence was another Arabian added in 1995. Occasionally a pony from the Maryland side swims around the ocean barrier and makes his way into the herds on the Virginia side. Since 1995, the fire company has strived to keep the breed pure.

The population of the Assateague Ponies on the Maryland side is controlled by contraceptive injections. In Virginia, the Fire Department's unique way of dealing with overpopulation on an island that has only enough foliage to feed about 150 ponies is an annual event called Pony Penning. Each year the ponies are rounded up in late July and penned on Assateague Island. On the last Wednesday of July each year firemen (nicknamed Saltwater Cowboys) swim the ponies across the bay and parade them down the streets in town to the carnival grounds where they are penned. Early Thursday morning the wild pony auction is held and foals are sold to the highest bidder, though select foals are sent back to the island to ensure the growth of future herds.

When children's author Marguerite Henry's book, *Misty of Chincoteague*, was published in 1947, Pony Penning was revealed to the world. Crowds trekked to Chincoteague Island to see the pony swim and auction; today, close to 50,000 people show up annually to become part of the magic.

As popularity has grown and the versatility of these ponies has become known, the cost of purchasing a piece of the legend has skyrocketed. Ponies that once cost $50 now average over $2,000. An occasional pony will sell for $500, but most go over $1,000 and buybacks have sold for as high as $17,000!

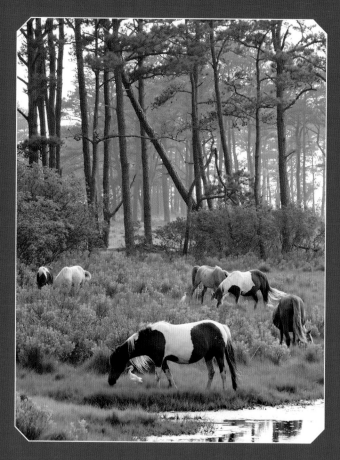

The Chincoteague Pony populations are split with some herds living on the southern portions of the island and more herds on the northern portions. Fencing, for the most part, keeps them in their designated areas. Here, a southern herd grazes alongside a freshwater pool. In this salty environment, the freshwater pools are a regular stop for the ponies.

OPPOSITE:

The Chincoteague National Wildlife Refuge, where the ponies live, was established in 1943 to provide a habitat for migratory birds, primarily the snow geese, and to protect endangered species, most notably the piping plover. The Chincoteague Fire Department holds a grazing permit on the refuge for 150 adult ponies. Here, a southern herd is grazing in a marshy inlet.

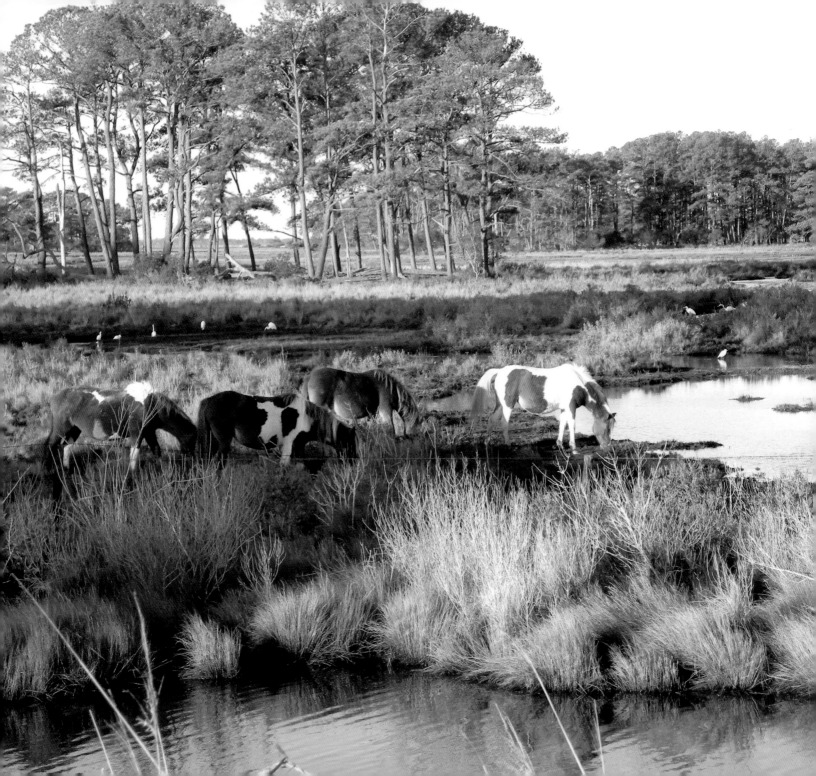

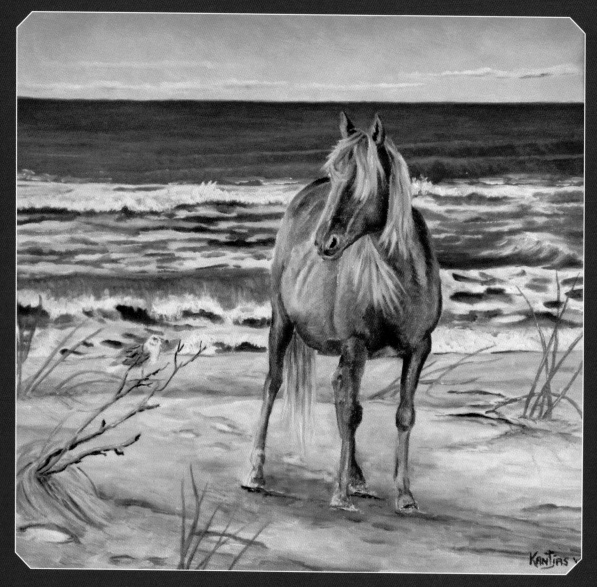

Chincoteague Ponies are called wild, but they are actually feral, which means they were domestic at some time in their heritage and became wild over time. The term "wild" is an odd word to use for these wonderful ponies, as they are used to interacting with humans and are rounded up three times a year for vaccinations and hoof care in the spring and fall and, again in the summer, for the world famous Chincoteague Pony Penning. In this painting, a pony stands on the sandy beach, one with the gulls. In the summer, when the air is thick with mosquitoes, herds sometimes wade into the ocean to stand, allowing the surf to sweep mosquitoes from their irritated hides.

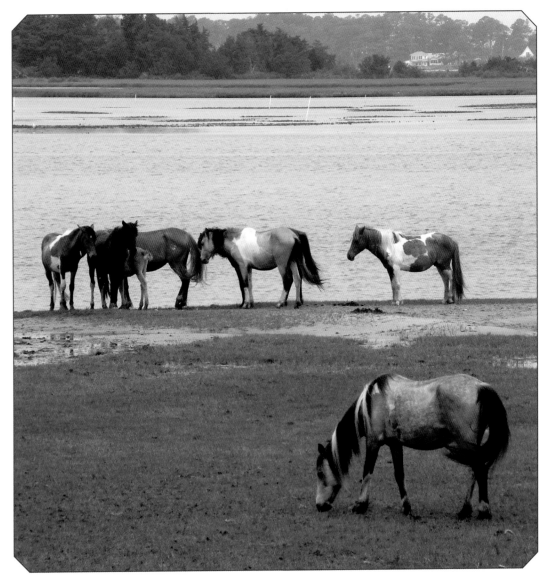

The chestnut and white pinto on the right is herd stallion **YANKEE SPIRIT**, also known as Spirit of Assateague. To the left of Yankee Spirit is buckskin pinto, **TORNADO'S LEGACY**, known as Lil' Tornado and named after his father, a famous herd sire named Tornado. When Tornado aged, he was removed from the island to protect him from injury by younger stallions fighting for mares. He was placed with Deb and Tom Ober, owners of Hawkeye Stables, in Easton, Maryland.

The colt on the left is **AJAX**. He stands next to **BLACK TIE AFFAIR**, also known as Ace, a buyback foal purchased by Debbie Folsom, and the buckskin pinto in the foreground is a mare named **MERRY TEAPOT'S HIGH BID**, the buyback of Karen Peck.

A buyback pony is purchased at Pony Penning, but is sent back to the island as a future herd dam or sire. Buyers are allowed to name the foals and get a certificate recognizing their purchase. The foals are selected in advance by the fire department's Pony Committee who strives to keep the genetic pool fresh.

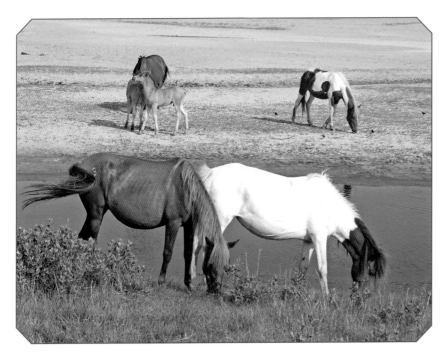

Ponies trek through water, mud, and muck daily. They survive on salty marsh cord grass, which is abundant on the island, but nutrient-poor. They also eat salt meadow hay, dune grasses and seaweed, twigs, greenbriar stems, persimmons, rosehips, bayberry twigs, and even poison ivy. Some call the pony on the right (in front) **CHOCOLATE DIP**.

This photo of the northern herds is an example of how wildlife coexists on the island. Two sika deer greet the ponies. Sika deer are also known as spotted deer or Japanese deer. They are natives of East Asia and were brought to the eastern shore area in the early 1920s by Boy Scouts who gifted them to landowners. They were prolific and quickly grew in numbers.

Plovers and egrets fish uninterrupted in the inlet while the ponies cross. The shore is lined with wax myrtle bushes, a fragrant bush that is plentiful on the island. Behind them, loblolly pine trees stretch to meet the sky.

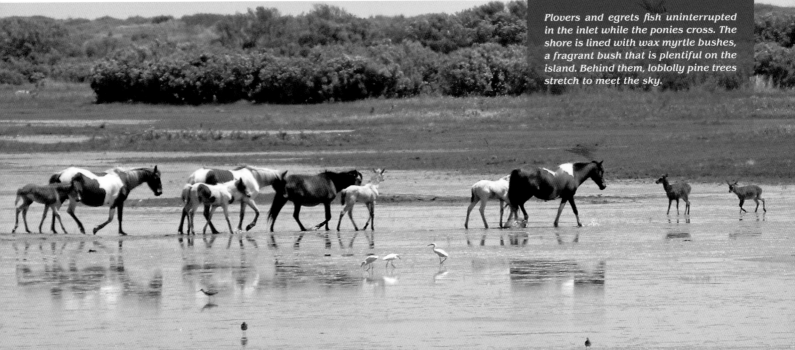

*This painting is of the mare **Dream Catcher.** Mares generally produce one foal per year. The powerful antibodies found in the first few days of milk (called colostrum) and the milk that follows supports the foal as he quickly learns to eat tender grasses.*

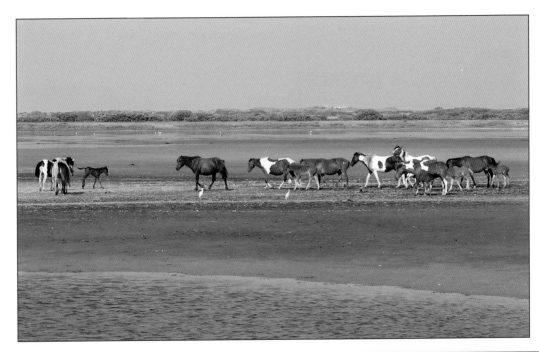

Here a northern herd crosses an area known as the salt flats. The 13,682-acre Chincoteague National Wildlife Reserve contains wooded areas, inlets and marshes, meadows, and freshwater ponds. More than 320 species of birds share the island with the ponies. Herons, egrets, marsh hens, ibises, oyster crackers, and other shorebirds are frequently spotted along the marshes. On the beaches, dozens of species of sandpipers, plovers, gulls, and terns feed, nest, and raise chicks. Songbirds flit among the bushes along the wildlife loop. Raccoons, red fox, sika and whitetail deer, the rare Delmarva fox squirrels, rabbits, muskrats and Virginia opossums, shrews, mice, rats, voles, snakes, and turtles also share their habitat.

Several herds graze between the flats and the northern corrals. The fire company keeps two sets of corrals on the island; one at the south end and one at the north end. The corrals are used to pen the herds for health checks and to have their hooves trimmed. During Pony Penning week (the last full week of July each year), the herds are rounded up and penned prior to the swim and auction — the southern herds in a pen on their end and the northern herds on the north end. On Monday of that week the northern herds are brought from their pens to join the herds in the southern pens. Crowds visit the ponies there until the swim on Wednesday.

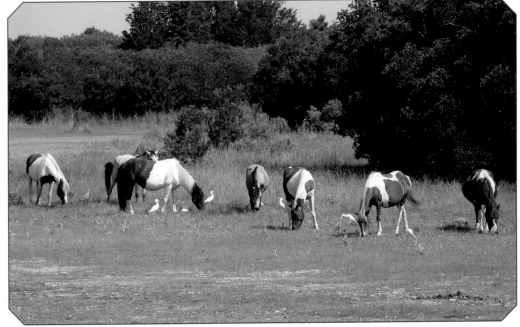

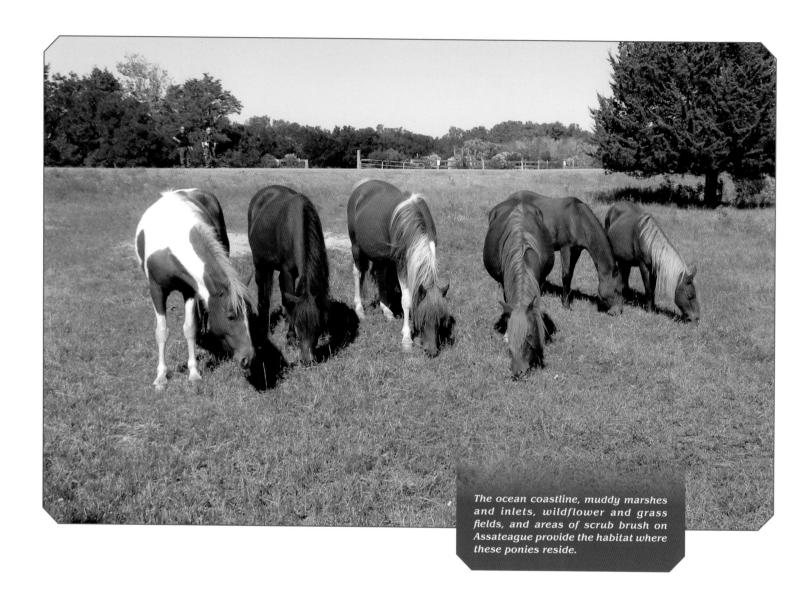

The ocean coastline, muddy marshes and inlets, wildflower and grass fields, and areas of scrub brush on Assateague provide the habitat where these ponies reside.

Chincoteague Ponies typically have long, thick manes. Their manes and tails sometimes appear to be dreadlocks, rolling together with the help of the wind and mud. Manes serve a dual purpose: protecting the ponies from bugs in the summer and cold in the winter. Sometimes long, tangled strands get hung up in briars or the barbed wire fences that keep the ponies out of areas the park service has designated as "protected" for endangered bird species or the endangered Delmarva fox squirrel. Many species of birds collect mane and tail hair for nest-building. This photo shows layers of foliage in the background, starting with the tall pampas grass, even taller wax myrtle bushes, and followed by pine and deciduous trees.

Here, a herd makes a stop at a vernal pool on the north side. The word "vernal" means spring. Vernal pools catch runoff water and sometimes have water only in the spring. Vernal pools are an important part of an ecosystem and are considered endangered. They offer a clean water source for songbirds and other wildlife, including ponies.

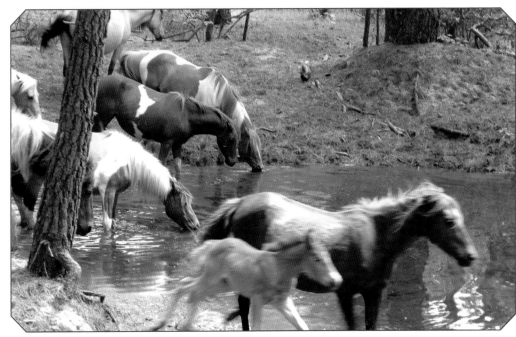

16

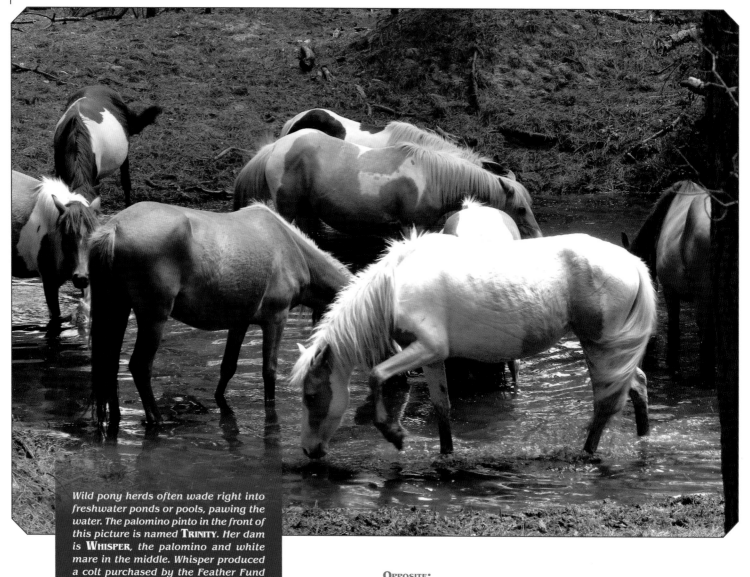

Wild pony herds often wade right into freshwater ponds or pools, pawing the water. The palomino pinto in the front of this picture is named **TRINITY**. Her dam is **WHISPER**, the palomino and white mare in the middle. Whisper produced a colt purchased by the Feather Fund in 2009 for a child who later named it Wild Wings of Assateague. The Feather Fund helps children purchase ponies at the Pony Penning auction.

OPPOSITE:

The lone pony at this vernal pool is named **MYSTERY**. *She was not born on the Virginia side of Assateague Island and no one knows where she came from. Occasionally, a pony from the Maryland side of Assateague Island will swim around the barrier to the Virginia portion of the island, but Maryland herd manager and biological technician, Allison Turner, said no Maryland mares were missing during this time period, so the pony's background remains a true mystery.*

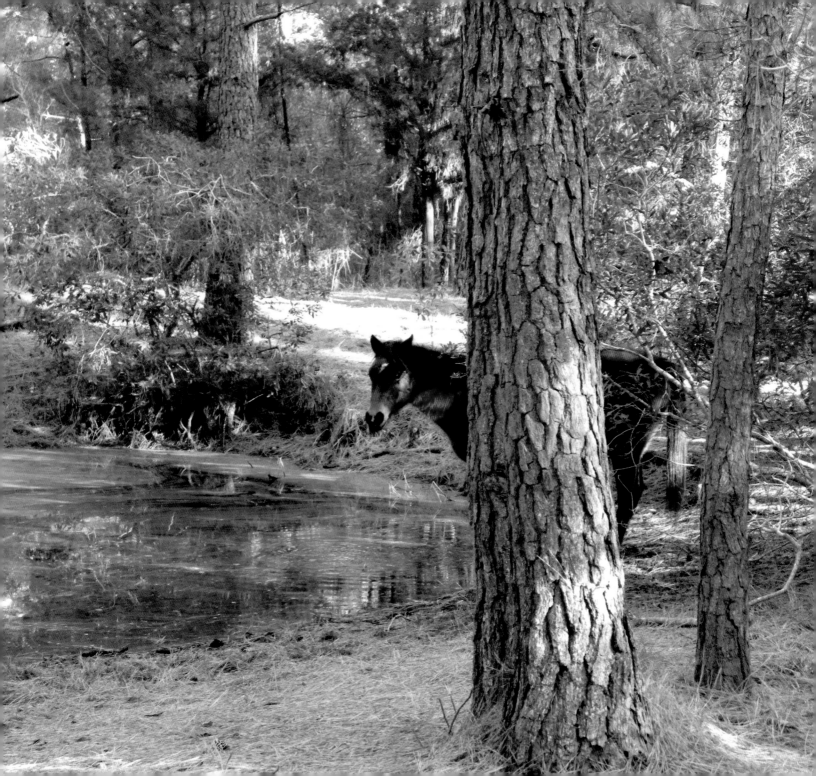

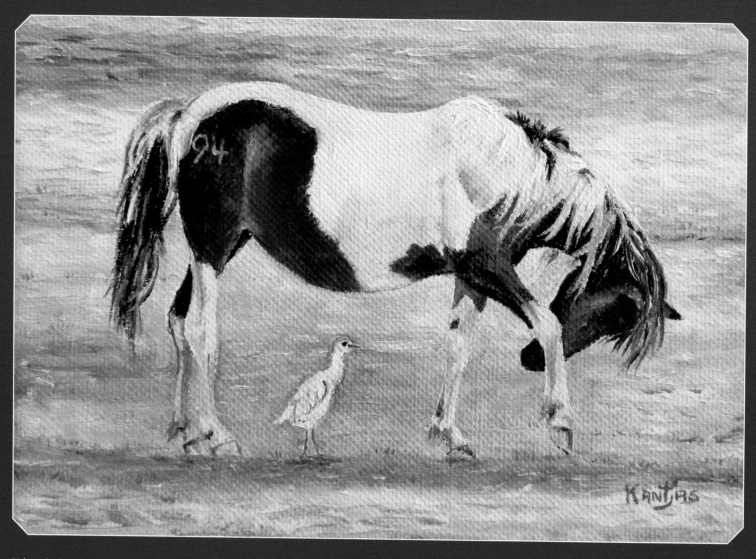

This painting was created from a photo of **BINKEY'S BREEZE.** *The symbiotic relationship between bug-eating birds and the ponies is necessary for survival on the island. The cattle egret survives on the mosquitoes, flies, and bugs he plucks from the pony and the pony gets relief from bugs in return.*

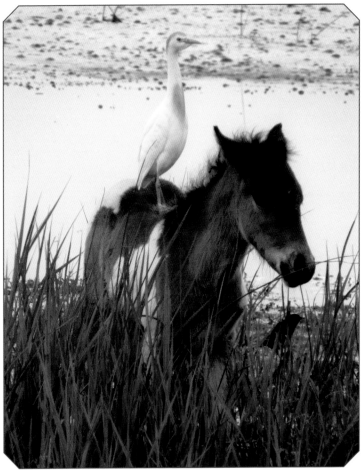

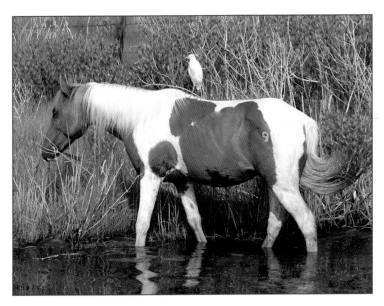

Cattle egrets are often seen standing on the ponies' backs on Assateague. They seem to know they are partners in life. This picture shows the popular stallion **NORTH STAR** wading along the water's edge and munching marsh grass.

This foal stands in tall marsh grass with an egret on his back. There are lots of bugs in the smelly, mucky salt marsh areas of Assateague, but the island offers more than bugs and ponies. The Chincoteague National Wildlife Refuge has educational programs so children and adults can learn about a variety of island topics, including wildlife and the cultural history. It also offers craft and game sessions as well as opportunities to explore the outdoors under the guidance of a refuge employee or volunteer. The list of programs includes bird walks, crabbing and surf fishing demonstrations, marsh walks, and photography hikes. You could join a walk through the wetlands, listen to lore around a beach bonfire, or watch the critters get fed daily at the center's aquarium. Check out the center's website for a list of programs.

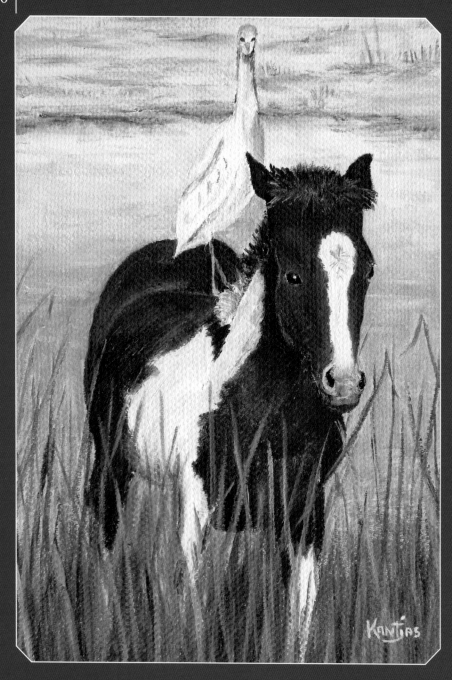

A good place to find ponies and egrets together is on the Wildlife Loop (where the photo for this painting was taken). Visitors can travel the Wildlife Loop on foot or by bicycle while the park is open or by vehicle from 3 p.m. to dusk. The Wildlife Loop is 3.2 miles long and includes a 1.6-mile-long Woodland Trail that forms a loop through the forest. On the right side of the loop is the wild pony overlook, a spot where visitors can stop and view the marsh. It is one of the most reliable places to spot Chincoteague ponies at a distance. Another trail, the Black Duck Path, leads from Beach Road through the marsh and onto the Wildlife Loop. This trail offers many opportunities to photograph blue herons, box turtles on land, and painted turtles sunning on logs or swimming in a canal with other varied marsh life.

OPPOSITE:

MERRY TEAPOT'S HIGH BID is seen here grazing with an egret by her side. Karen Peck bought the mare in 1991 before the fire department implemented the buyback program. The fire company named her Merry Teapot after a woman named Mary Teapot, who was a member of the Fire Company's Ladies Auxiliary. Years later, when the buy-back program began, Peck had her registered with the name "High Bid" so they combined the names.

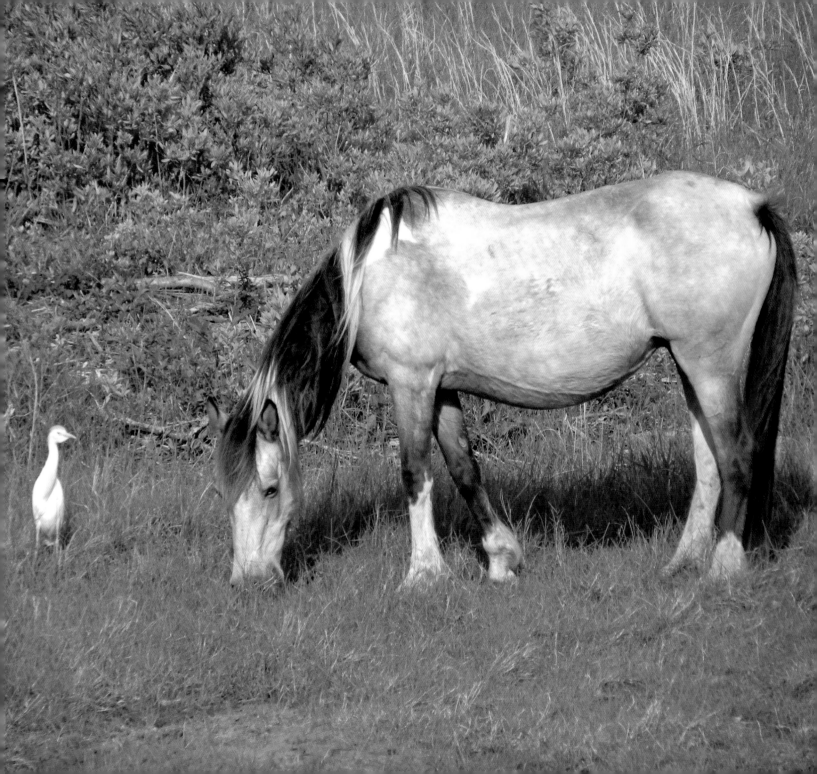

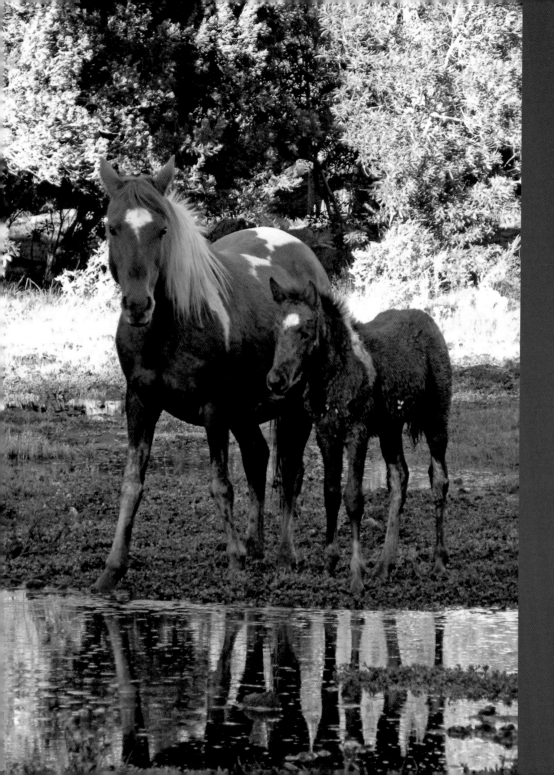

Their Stories

A bay foal chews on the neck of **MIDNIGHT DREAM**, *Dream Catcher's 2009 black foal. When foals nip and chew in play, the behavior is a precursor to intentional nipping as an adult, used as discipline, a warning, or to scratch each other's itches.*

The mare **LADY HOOK** *stands with her 2010 foal, all muddy after a romp in the marshes. Her foal was sired by Miracle Man and was purchased by a family from Canada.*

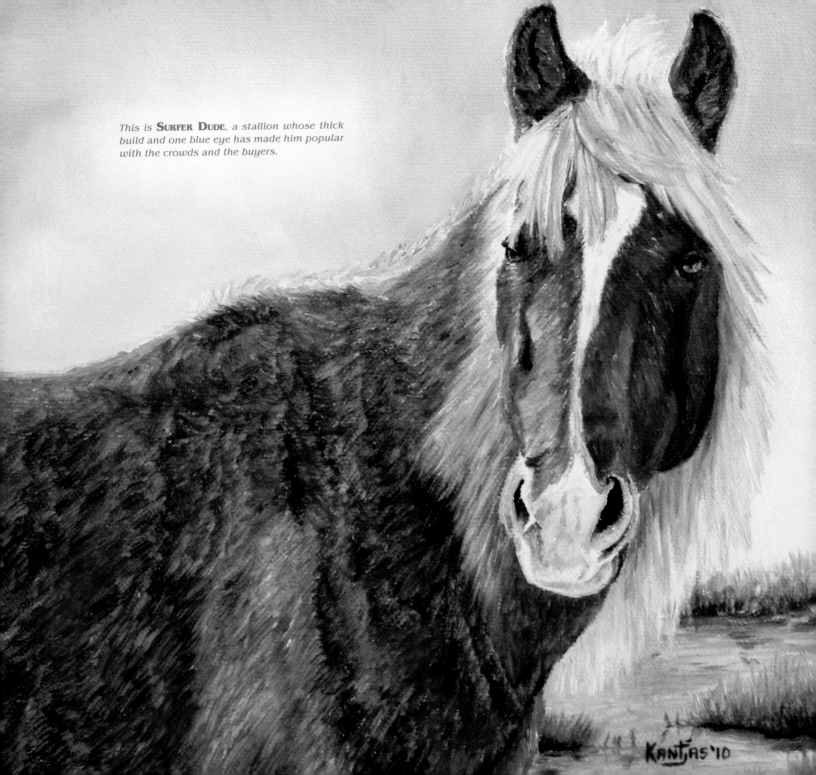

This is **SURFER DUDE**, a stallion whose thick build and one blue eye has made him popular with the crowds and the buyers.

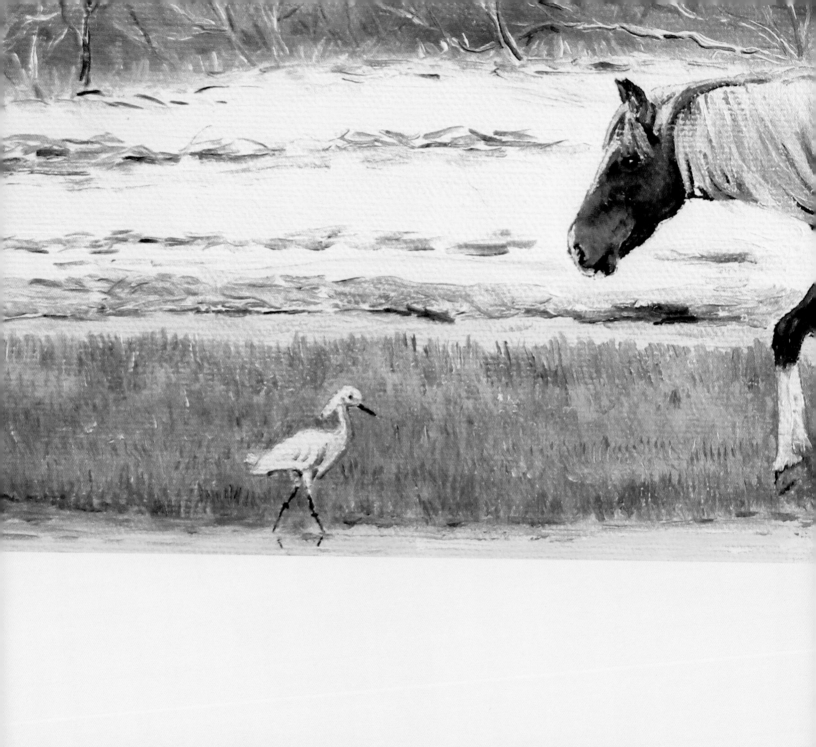

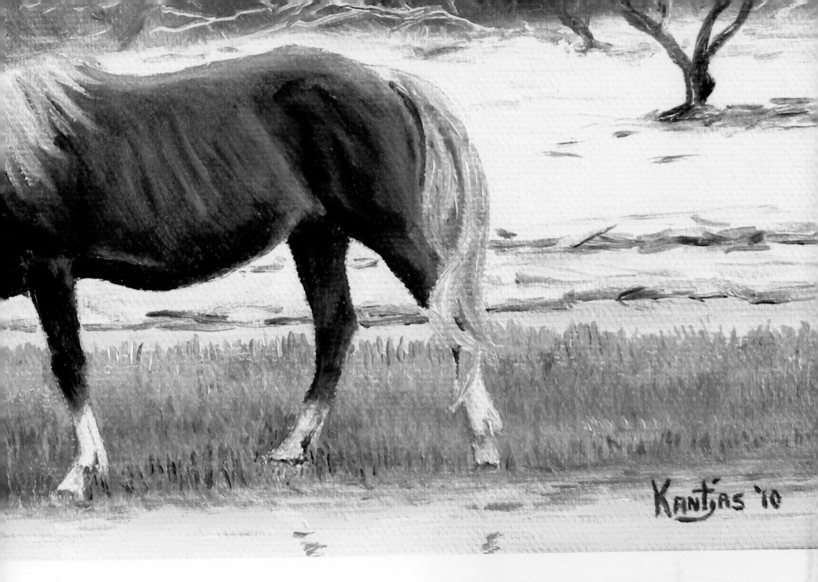

SURFER DUDE greets an egret on the island. Surfer Dude's dam was one of several mustangs placed on the island to upgrade the herd's size and keep the genetic pool from becoming stagnant. His father was a stallion named Pirate that was given the nickname "Broken Jaw" after his jaw was fractured by another stallion in a fight. Pirate also had mustang parentage and perhaps that accounts for his indomitable will to survive. Park employees say Pirate was expected to die after his injury. His jaw jutted out at an odd angle and most believed he would not be able to eat, but he did. When Pony Penning time came around, officials decided he was in no condition to make the swim, so they barricaded him away from his mares. He jumped the fenced enclosure and was soon with his mares again. On the day of the swim, they separated him once more. As the ponies entered the water, the cowboys heard pounding hooves. The stallion with the broken jaw had escaped. He plunged into the water to swim with his mares. They say a stallion's will is hard to break. They never tried to separate him from his mares again.

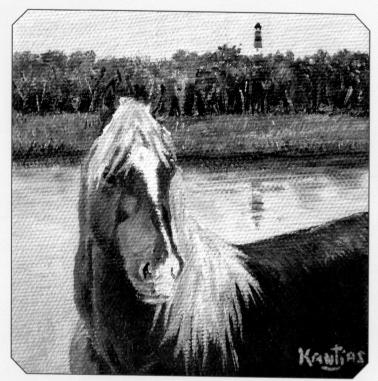

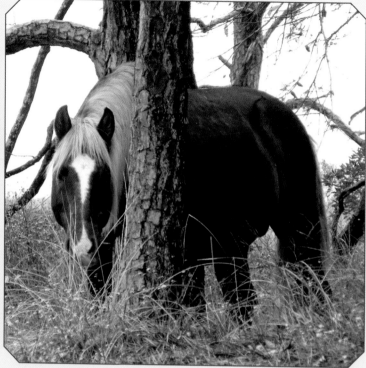

SURFER DUDE stands before the Assateague Island Lighthouse. Prior to 2004, the lighthouse was only open to visitors invited by the United States Coast Guard. Ownership of the lighthouse was then transferred to the Fish and Wildlife Service, which opened it to the general public. Listed on the National Register of Historic Places, this lighthouse was constructed in 1833 at a cost of approximately $55,000. It had a 45-foot tower, but was too short to effectively light the Atlantic coast. Construction to make it taller began in 1860, but was suspended during the Civil War. The existing 145-foot high lighthouse was completed and lit in 1867. It has a base that measures over 27 feet in diameter. Until it was converted to an electrical lantern in 1933, the lighthouse used a candle lantern. Originally a solid red lighthouse, it was painted red and white in 1969. Visitors can climb the Assateague Lighthouse to view the ponies and the abundant waterfowl at the National Wildlife Refuge. From spring through fall scheduled art and photo exhibits are set up in the oil house at the base of the lighthouse.

This photo shows **SURFER DUDE** "hiding" behind a tree. Those who know this stallion laugh at the way he always seems to slip behind a tree as if he is hidden from sight.

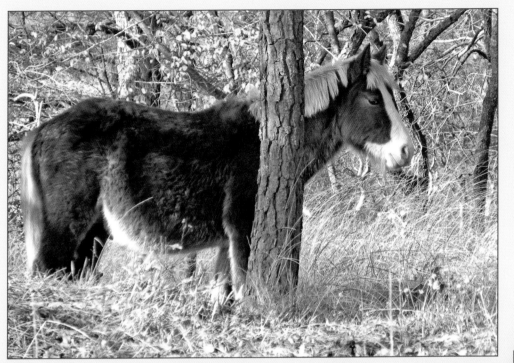

This is Surfer Dude's son, **SURFER'S RIP TIDE**. *He seems to be adopting his sire's habit of hiding behind trees. The year Rip Tide was born the fire department did not plan to keep any colts, only fillies. They had enough young stallions coming up, but when a Surfer Dude look-alike was in the mix and they realized his popularity, they knew they should keep the colt. Even in the depressed economy of 2009, this buyback colt sold for a whopping $11,700.*

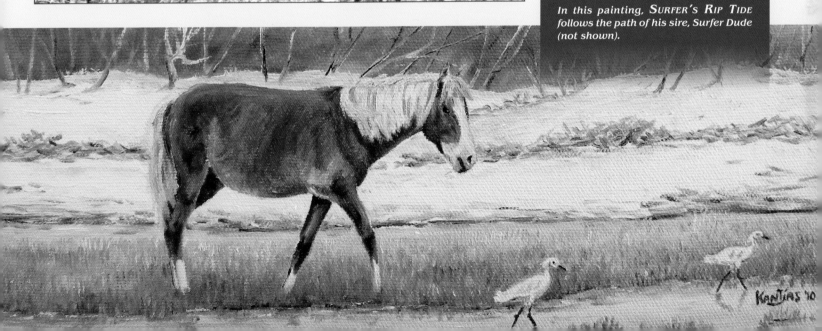

In this painting, SURFER'S RIP TIDE follows the path of his sire, Surfer Dude (not shown).

KANTIAS '10

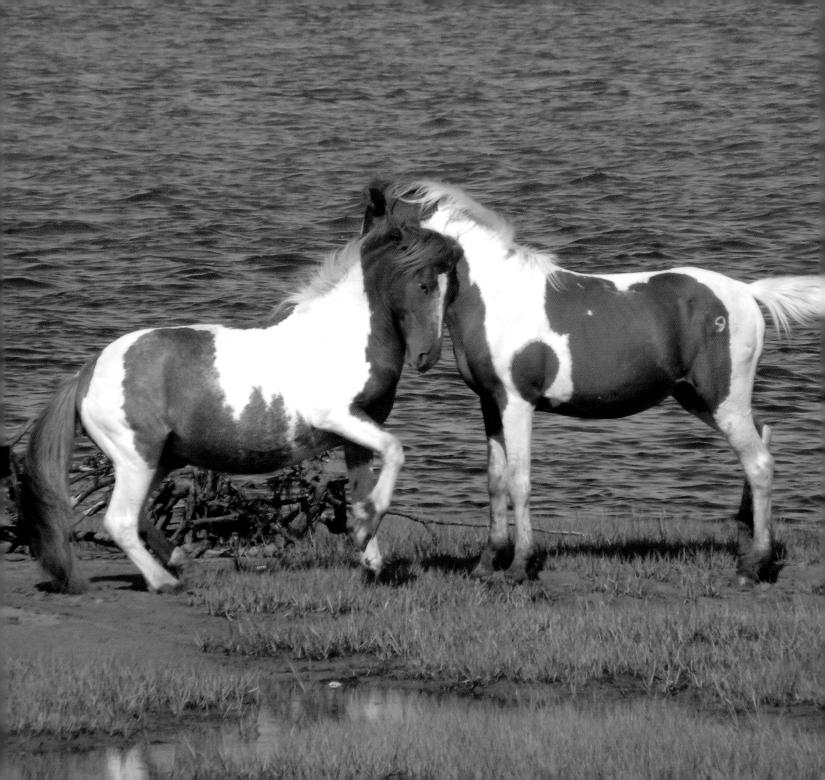

OPPOSITE:

Stallions on the island fight to keep their mares or to steal new mares. On the left is **YANKEE SPIRIT** *(also called Spirit of Assateague or Spirit) and he is facing off with* **NORTH STAR.** *Spirit once lived on the Maryland portion of the island and was adopted from the National Park Service in Maryland by Liz Spino. Ponies on the Maryland side can be adopted by more than one individual. This simply means they have sent a donation to help support the pony. They receive a letter and a photo in return. Several times Spirit has left the Maryland side of Assateague, swimming around the state barrier to join the Virginia herds. Liz Spino knew the pony because of the adoption. She informed the pony committee who he was, sharing her paperwork. Several times they took him back, but finally, he earned the right to stay. At 21-years-old, he is one of the oldest stallions on the island.*

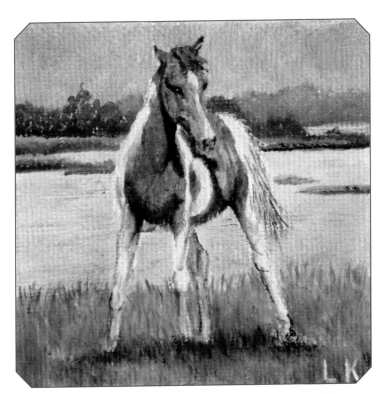

The stallion **NORTH STAR** *was sired by an Arabian stallion named Premiere, placed on the island to upgrade the herds and keep the genetic pool fresh.*

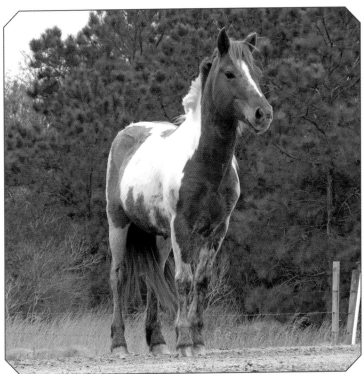

YANKEE SPIRIT *(also called Spirit or Spirit of Assateague).*

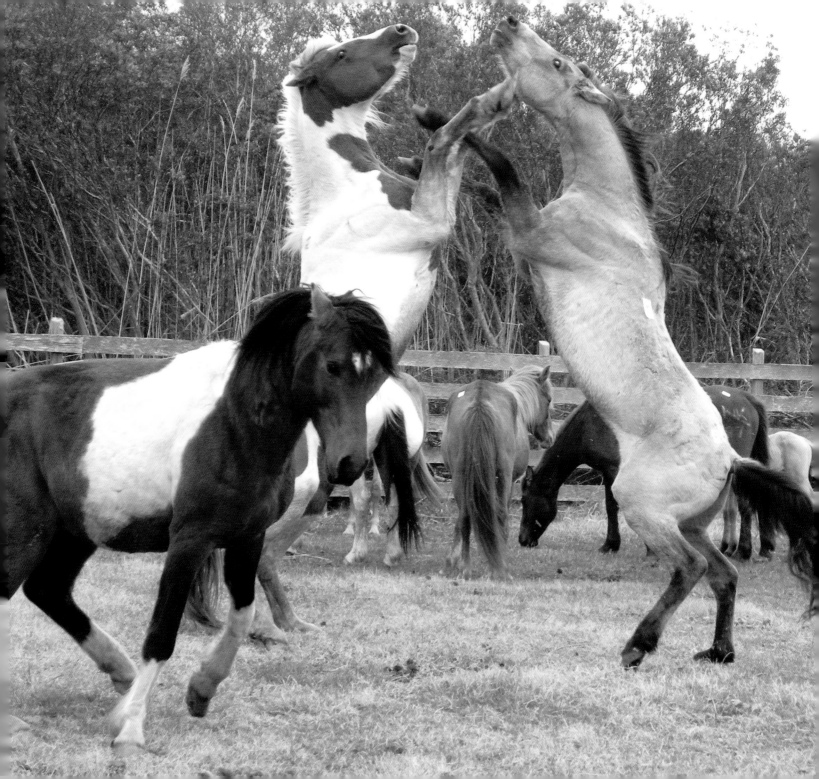

LEONARD STUD, *nicknamed "The Donald," is recognized by his big jaw and Arabian characteristics.*

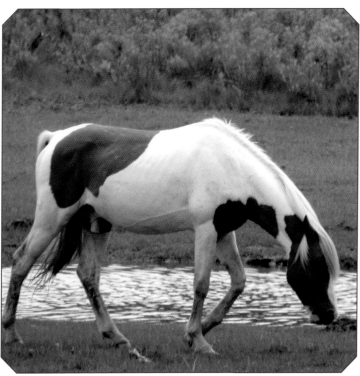

Often, before two stallions fight they lower their heads and swivel their necks back and forth in a motion known as snaking. This motion is also used when stallions are watching over their mares. LEONARD STUD *is snaking in this photo. According to many who observe the ponies, "The Donald" is one of the most watchful stallions and he keeps close tabs on his mares.*

OPPOSITE:

LEONARD STUD *(left) and* COPPER MOOSE *(right) go head-to-head in a typical fight between stallions.* SOCK IT TO ME *(sometimes Sockett to Me) is in the foreground. Leonard Stud was donated to the island by the Leonard family and is named after Donald Leonard, the patriarch of the Chincoteague Pony Farm, which lies on the north point of Chincoteague Island. Donald Leonard passed away in 2010, but his legacy lives on through the ponies his selective breeding has influenced. The Leonard family also owns The Refuge, a motel located next to McDonalds on Chincoteague Island. Visitors often stop to visit the Chincoteague ponies fenced at The Refuge.*

Leonard Stud.

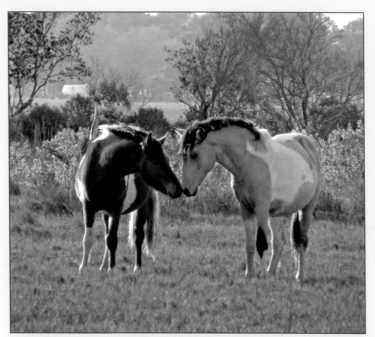

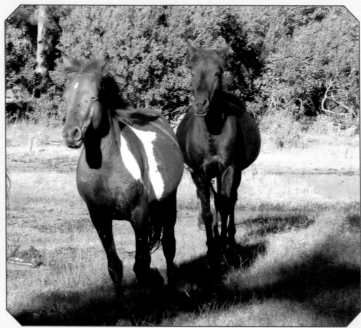

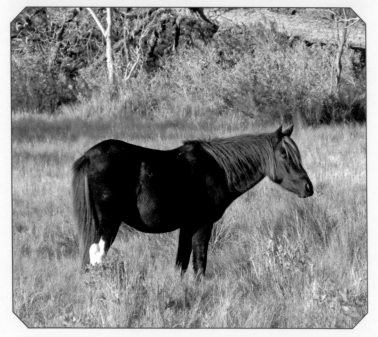

Top Left:

Two three-year-old colts greet each other in the wild: **Ajax**, *on the left, and* **Tornado's Legacy** *(also known as Lil' Tornado), on the right. Soon they will begin to establish herds of their own.*

Top Right:

Ajax *and* **Black Tie Affair** *(known as Ace) kick up their heels and the mud flies. Ajax may have his eyes closed to keep the swarm of bugs out of them. Mosquitoes are so prevalent on the island that one popular t-shirt states, "I gave blood at Chincoteague Island."*

Bottom Left:

Black Tie Affair *stands alone in a marshy meadow. The fallen tree in the background is evidence of a blight that hit the island in the late 1990s, destroying many trees.*

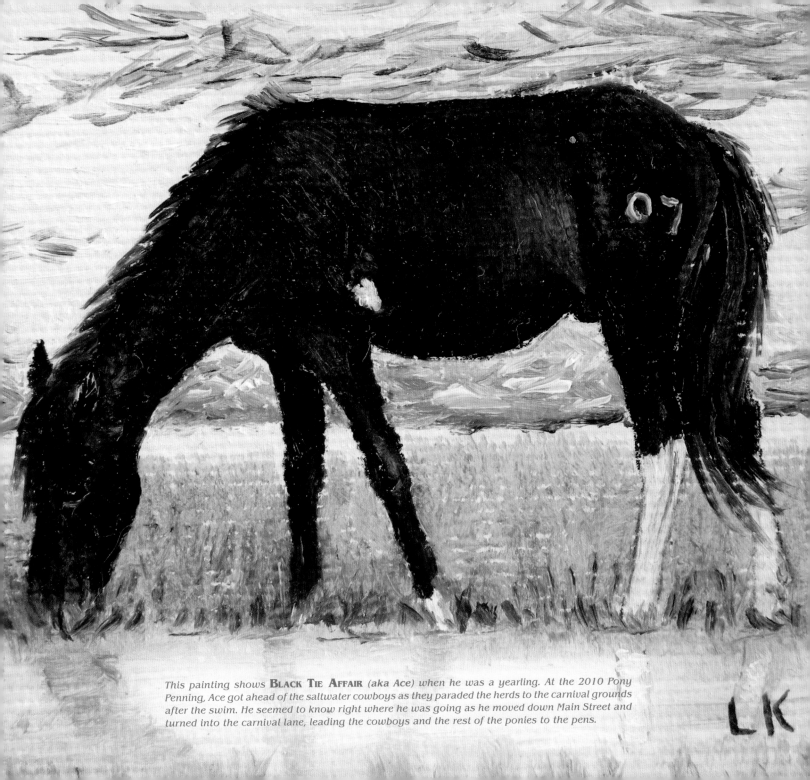

This painting shows **BLACK TIE AFFAIR** *(aka Ace) when he was a yearling. At the 2010 Pony Penning, Ace got ahead of the saltwater cowboys as they paraded the herds to the carnival grounds after the swim. He seemed to know right where he was going as he moved down Main Street and turned into the carnival lane, leading the cowboys and the rest of the ponies to the pens.*

LK

The stallion **SOCK IT TO ME** *(on the left) greets the stallion* **COURTNEY'S BOY**
(also known as Old Rainbow Warrior). A battle is about to ensue.

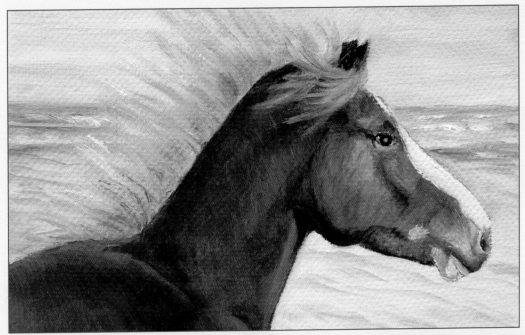

This colt is named **KEN**. He was purchased as a buyback in 2008 by Sue Lowery of Ohio with help from a good friend. Lowery's uncle, Ken Stanley, had died that year. He was a Shriner. "Much of his adult life was spent trying to do for other children what could not be done for his son," Lowery said. "As a teenager I watched my uncle lose his only son to leukemia."

Here is the other side of **KEN**. Sue Lowery said some call the white mark on her buyback Ken's face a kiss, but she calls it a butterfly. The white splotch has become his trademark.

Lowery said she loves that Ken was hers to name and she plans to watch and admire him as he grows up on the island. She's heard complaints that Ken is not a strong enough or eloquent enough name for an island stallion and she has a response. "They did not know my uncle."

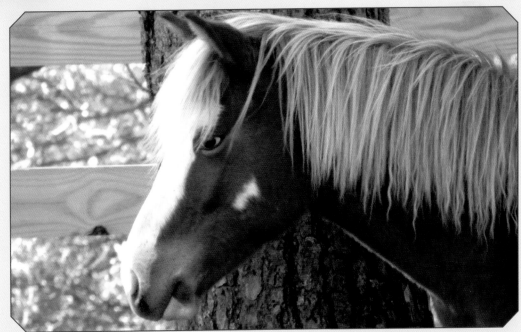

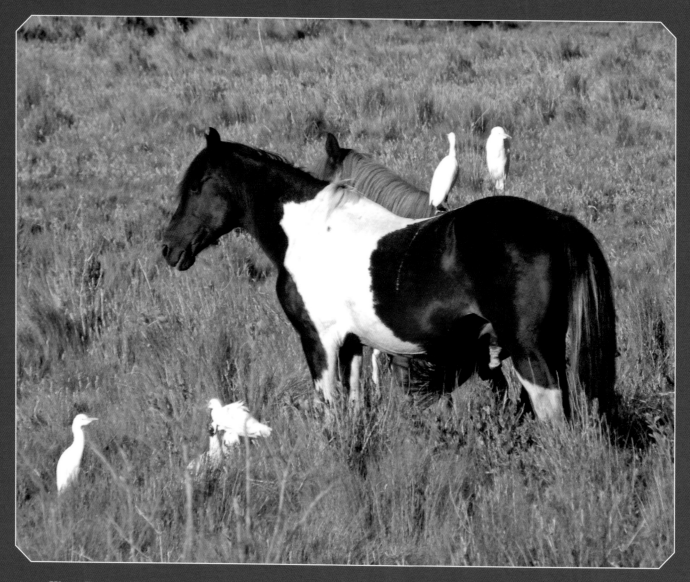

This is **WITCH DOCTOR**. *He was sold as a foal and taken to New York State. When he was a full-grown stallion, he found a way to get in with forbidden mares. A call was made to the fire department. Would they take him back? They did and he was returned to the island. Here, Witch Doctor stands next to one of his chestnut mares with their egret companions. The stallion has three nicknames: Some call him "New York Stud" while others say his name is "Sea Biscuit." However, many call him "Oreo" because he is white in the middle and dark on both ends.*

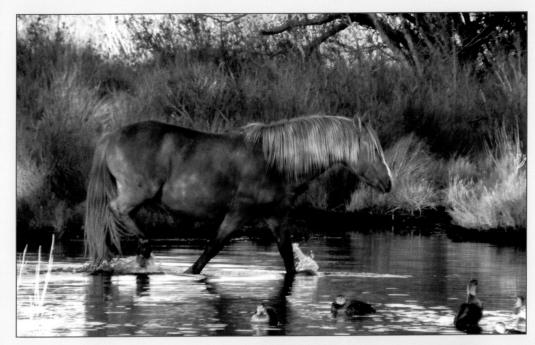

The stallion **PHANTOM MIST** treks through the water while ducks float nearby. Phantom Mist was long-ago nicknamed "Fabio" because he is proud, well-muscled, and likes to strut his stuff.

PHANTOM MIST (nicknamed "Fabio") stands proud and watchful in a watering hole on the south side.

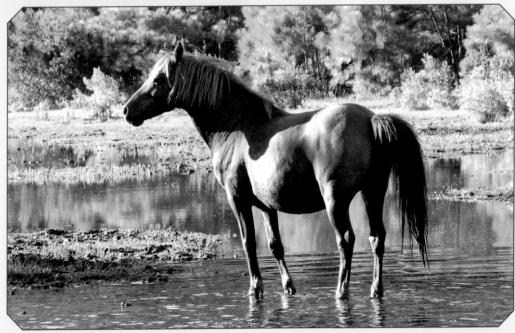

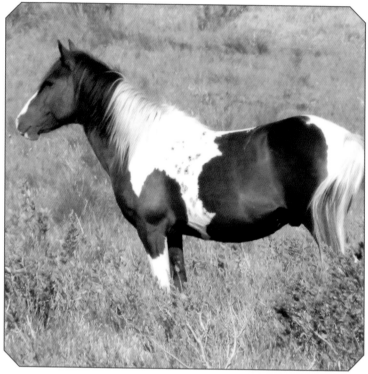

*This is **MIRACLE MAN** (right) with **LADY HOOK**. He was an orphan foal found in the Black Duck Marsh by Arthur Leonard in 1995. Leonard was in dress clothes and shoes when he spied the deserted foal. Still, he jumped into action and waded into the marsh to save the foal. The foal was very still until he saw Leonard. Then he sprang to life, darting away each time the man drew close. As darkness fell over the island, Leonard called his wife on his cell phone and she called the fire company, which brought a truck to shine headlights across the marsh and a fishing boat to cross the water. At last the motherless foal was captured. A veterinarian examination revealed more: The foal had been alone for several days. He had an abscess in his eye and another in his leg. The rescued foal was named Little Arthur. Another mare, whose foal had just been weaned and had plenty of milk, was chosen to nurse him, but she was unwilling. She kicked and bit at the colt. Leonard knew just what to do. He tied one leg up with rope and gave the mare a bucket of grain. She munched the grain, clearly agitated by the colt nursing on her, but there was nothing she could do. If she kicked, she'd only have two legs to stand on and she'd fall over. So the colt nursed.*

Ointment healed the eye, but the leg grew worse. The vet had done all he could do. The Leonard family removed the bandage and allowed flies to lay eggs in the wound. When the eggs hatched, the maggots ate away the infection. At last the foal began to heal, but winter was coming and a bad one was predicted. A friend agreed to take him home to Florida. When the colt came back to Chincoteague the following summer, he was brought into the auction ring at Pony Penning. He shook hands, bowed to the crowd, and gave his handler a kiss on the cheek. Before he was released on the island to sire his own foals, he was renamed Miracle Man.

__MIRACLE MAN'S__ left side freckles make him easy to identify among other bay pinto stallions on the island. He's a smart pony. Visitors coming onto the island early for the 2008 Pony Penning found Miracle Man already at the carnival grounds. When the saltwater cowboys began rounding up the ponies the Saturday before Pony Penning, Miracle Man knew what was going on. It happened every summer. He decided to skip the pens on Assateague Island and herded his mares into the channel to swim, coming in at Memorial Park, just as they do during the annual swim. Frantic islanders called the saltwater cowboys who showed up to take Miracle Man and his mares to the carnival grounds — four days early!

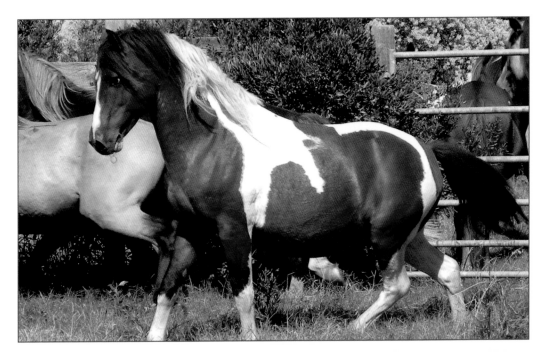

This is **WILD THING**, a powerful stallion with a reputation as troublemaker. This photograph was taken during Pony Penning, a time when stallions are often stirred up by the proximity of other stallions to their mares.

The two stallions in the middle of this photo are **COPPER MOOSE** and **RAINBOW WARRIOR** (also known as Napoleon). Rainbow Warrior is stirring up trouble. The buckskin Copper Moose is the 1996 buyback of Ed Suplee and was so named because of his copper coloring and because Ed's nickname is Moose. Copper Moose was the high-selling buyback that year, going for $5,000.

A few years later, Ed's wife, Carollynn, purchased a filly identical to Copper Moose. Carollynn was a cancer survivor who believed in "giving back." Each year of survival after her diagnosis and surgery for a brain tumor, she purchased a foal for a child or a buyback as a way of "giving back" for another year of life. She named this buyback filly God's Grace. The mare lived four years and had one foal. She died from unexplained causes the very same year Carollynn passed. Some believe they are together in heaven.

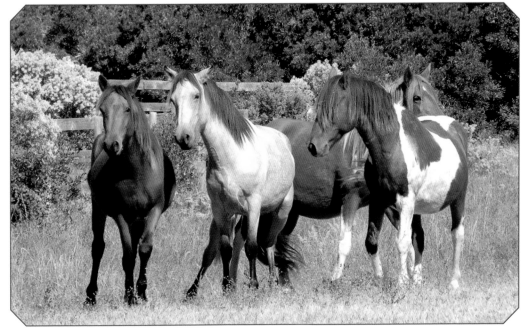

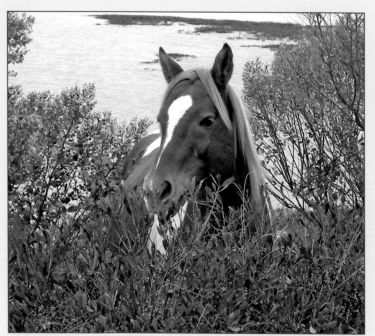

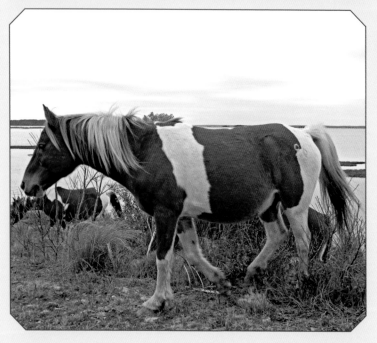

TOP LEFT:

The stallion **COURTNEY'S BOY** *(also known as Old Rainbow Warrior) is framed by wax myrtle bushes. In the Marguerite Henry book, Sea Star, Orphan of Chincoteague, the Beebe children rubbed fragrant myrtle leaves over an orphan foal's body and on the nose of the mare they had chosen to adopt and nurse the foal. The scent of myrtle on both of them made the mare accept the foal as her own and nurse it to health.*

TOP RIGHT:

COURTNEY'S BOY *races through a field of autumn weeds. As summer leaves the island so do green grasses and plentiful plants for foraging. The pines remain green, but the brightest patches of color are found on the birds — a splash of crimson on a red-winged blackbird or the bright green ringing a mallard's neck. Foraging ponies turn to berries and brown grasses and hay the firemen bring when winter turns snowy.*

BOTTOM LEFT:

COURTNEY'S BOY *leads his herd past an inlet. Fall has swept the leaves from the bushes and brought cooler, darker days.*

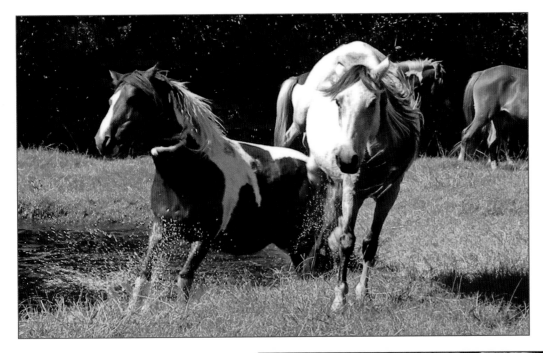

The stallion **WILD THING** kicks up water at a fall roundup as the mare **MERRY TEAPOT'S HIGH BID** jumps over him. The ponies are checked by a veterinarian during an annual roundup held in October. If late babies have been born, they are sometimes sold at this time.

TORNADO'S LEGACY (also known as Lil' Tornado) plows through muddy water. This young stallion is the son of Tornado, a well-known herd stallion that has produced many high-selling foals for the fire department before he was retired to a farm on the eastern shore. He is now owned by Tom and Deb Ober. Tornado was a wise old stallion. In 2007, his lead mare was kept on Chincoteague with her foal after Pony Penning. The foal was a fall pickup. Very young foals are sold at auction as "fall pickups." This means the foal is kept on the carnival grounds with their dam until fall when it is old enough to be weaned. The buyer must return in the fall to pick up the foal. On the Friday after the Pony Penning auction, the herds were paraded down Main Street and back to Memorial Park to swim home. An hour later the firemen were called to return to Memorial Park. Tornado had come back to Chincoteague, swimming across the Assateague Channel alone, to retrieve his mare.

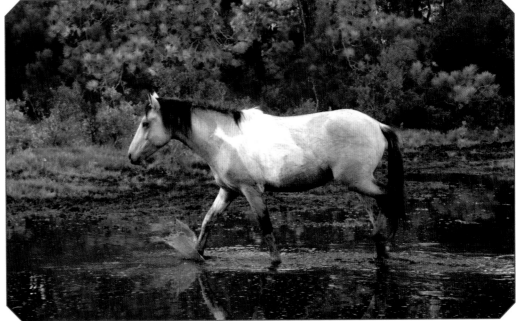

42

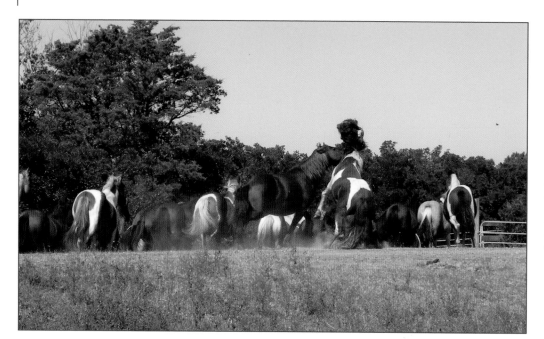

OPPOSITE:

Watching the cowboy action are three mares: (left to right) **E.T., GIRAFFE,** *and* **DREAM CATCHER.**

As the ponies trot into the pens at a fall roundup, **WILD BILL** *(also known as Cinnamon Hologram) bites* **RAINBOW WARRIOR** *(nicknamed Napoleon) — a clear warning to stay away from his mares.*

The stallion **MIRACLE MAN** *reaches out to mare,* **LADY HOOK.** *This photo captures a tender moment between a stallion and one of his mares.*

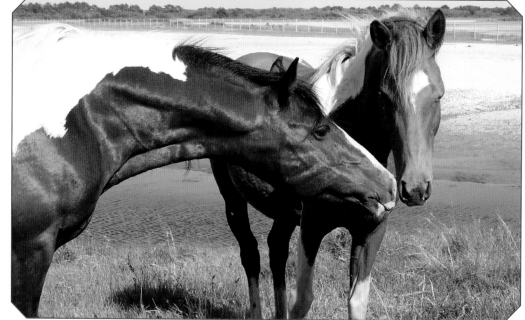

This painting is of a mare named **FRECKLES**. She was purchased by the Buyback Babes in 2006. The blue-eyed mare was named for the freckles on her sides. The Buyback Babes are a group of ladies from across the United States who pool their money to purchase buyback ponies.

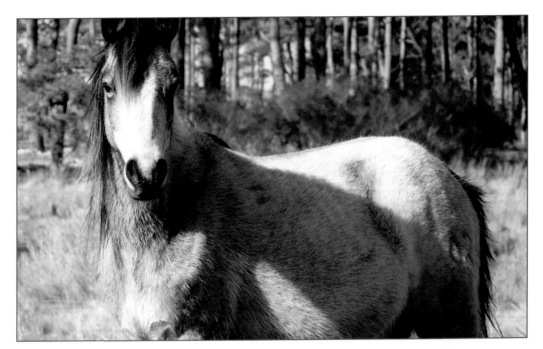

This coffee colored mare is named **Poco Latte**.

The mare **Paint by Color** (nicknamed Paint Butt) stands in a watering hole near the south pasture.

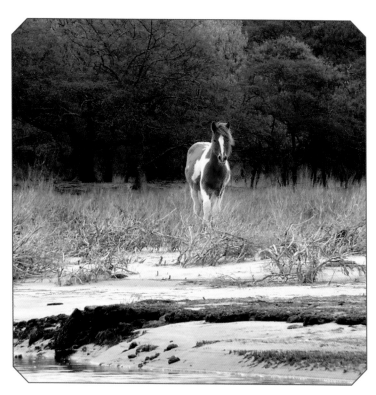

This looks like snow, but it is actually windblown sand. Chincoteague Ponies often brave harsh nor'easters and strong, cold winds. The pony is **COURTNEY'S ISLAND DOVE**.

This 2008 buyback mare by Miracle Man is named **AMERICAN GIRL***. She is also called "Wildest Dreams."*

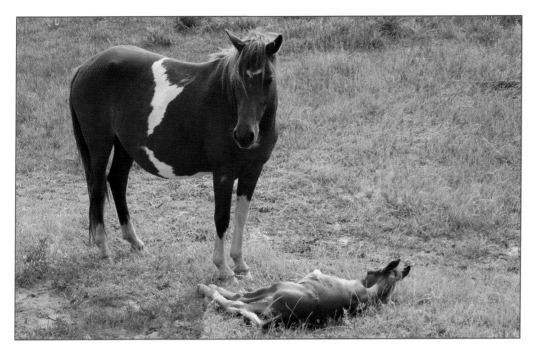

This mare is **CHECKMARK***. Some call her Checkers for short. Many of the Buyback Babes nicknamed her Butterfly before they knew her registered name. The butterfly marking on her side makes her easy to identify.*

E.T. *talks to her foal. The mare was purchased by Jean Bonde in 2002 and named for a marking on her side that reminded Bonde of the long finger of "E.T." from the film classic about an extraterrestrial. The mare also has a finger marking on the right side of her neck.*

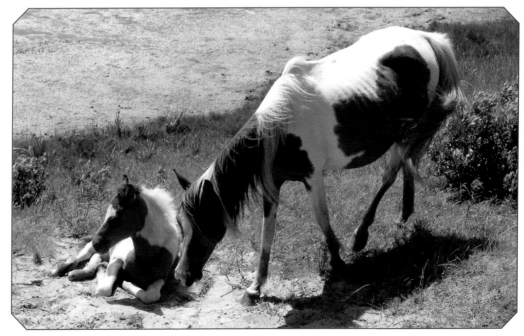

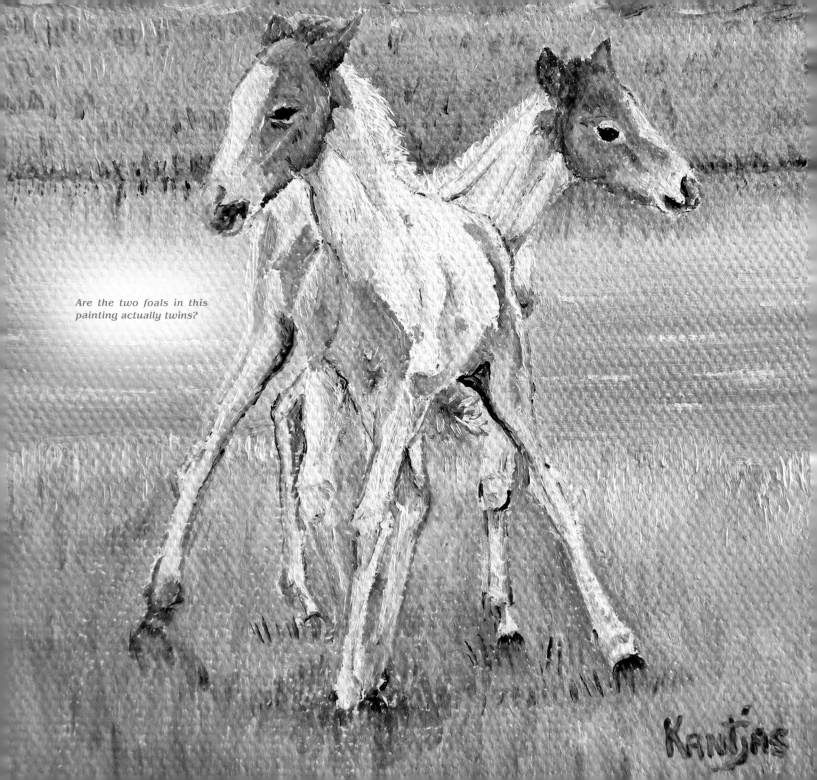

Are the two foals in this painting actually twins?

Kanijns

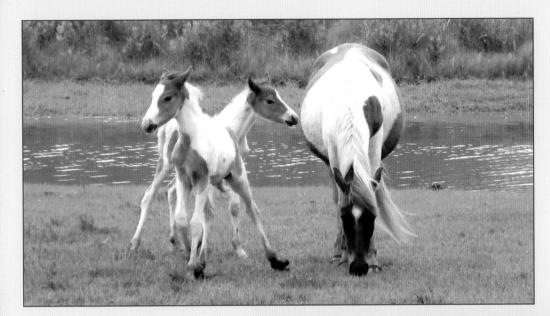

They look like twins, frolicking in the summer haze on Assateague Island.

But they are not! Here you see a painting with both mares. At this age, foals depend on a mare's milk, but also eat grass, often splaying their long legs to reach the ground.

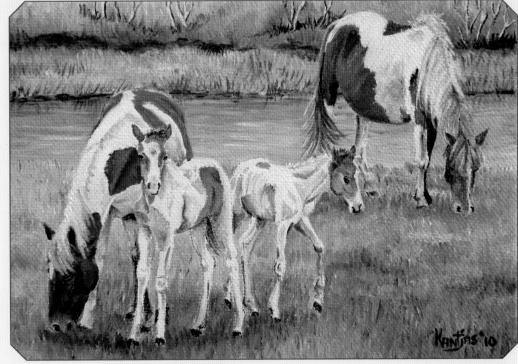

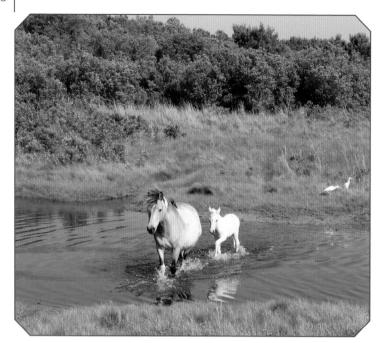

OPPOSITE:

*The mare **BABE** grazes with her foal, born after the 2010 Pony Penning. As winter approached, the Pony Committee worried about the newborn foal. The 2009/2010 winter had been uncharacteristically harsh and several foals had perished. Erring on the side of caution they brought this mare and foal to the pens on the carnival grounds to be cared for over the 2010/2011 winter season.*

*This is the mare **HONEY BEE** and her foal.*

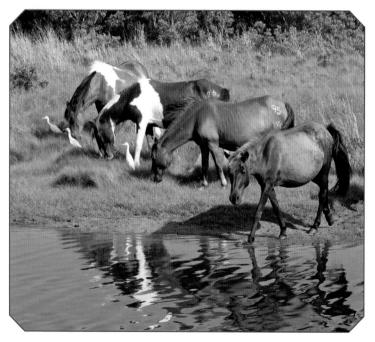

*About to enter the water is **NOAH'S SHADOW**. Her story is a wonderful one: In 1997, seventeen-year-old Noah Kauffman wished for one thing — to come from Englewood, Florida, to Chincoteague for the Pony Penning. He'd been born with kidney disease. When his doctors and nurses learned of his wish, they contributed to his airfare and coordinated a trip to the island for Noah. When Noah arrived, Chincoteague residents and business owners took over, making arrangements for his hotel, restaurants, and transportation. Donald and Mary Lou Birch, owners of the Birchwood Motel, did not charge him and his mother for their five-day stay. One resident drove him to the hospital in Berlin, Maryland, for his dialysis.*

David Sanz, a visitor himself to the Pony Penning, had seen a sign at the motel welcoming Noah and his mom and soon learned the full story. A foal had been born two days before the auction and was to be a buyback. Sanz approached Noah and asked him if he would like the pony. After an adamant "yes," Sanz bid $1,000 and Noah got his pony. They put a special brand on Noah's filly, which helps visitors to recognize her. Currently, she is with the northern herds.

*Also in this photo is **ISLAND BREEZE**, the pony in the back. The stallion in the middle and tattooed with "96" is **WILLIE**, also known as "Old Courtney's Boy." The chestnut pony tattooed with "95" is **ISLAND DREAM**. The numbers on the pony's hips indicate the year the pony was born. Ponies were once branded with their birth year, but now the Chincoteague Fire Department Pony Committee also microchips buyback foals for identification*

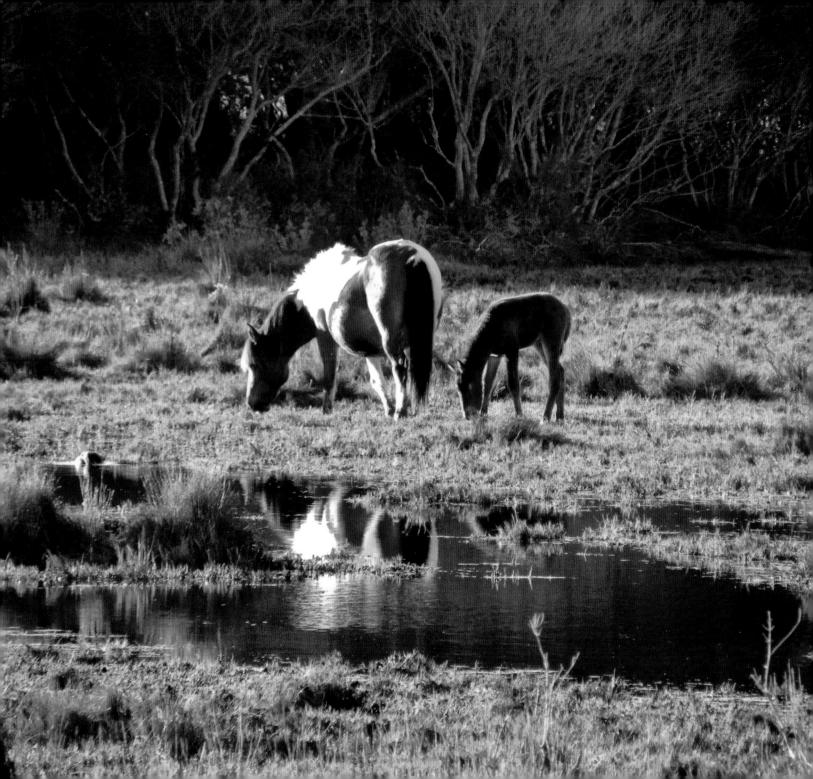

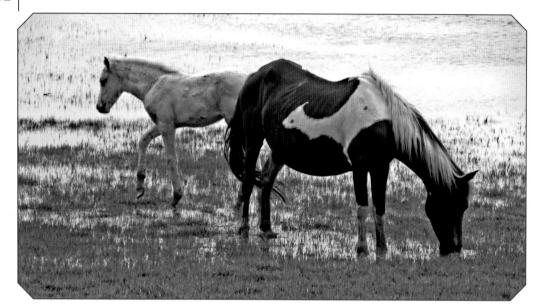

LIVING LEGEND grazes in the marsh with her 2011 foal.

During periods of drought, the tidewater inlets become dry and barren. In the back, the stallion WILD BILL (also called Cinnamon Hologram) urges a buckskin mare forward and across the flats. The mare to the right is DREAM CATCHER with her attractive black foal.

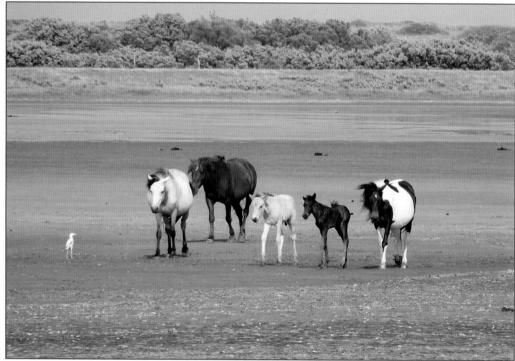

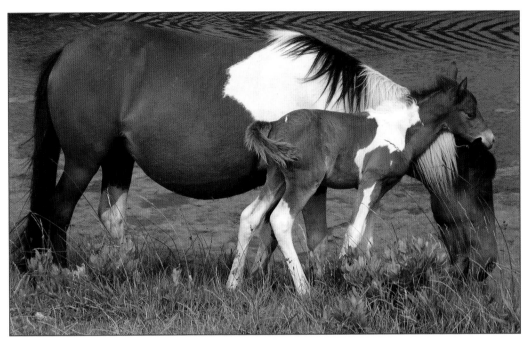

*This is **LITTLE FREEDOM** and her foal. Little Freedom is the granddam of the blue-eyed mare named Freckles.*

*Three of Surfer Dude's mares and their foals hang out with **SURFER'S RIP TIDE**, the buyback colt that sold for $11,700 in the 2009 auction. The chestnut mare on the left is Surfer's lead mare, **SURF QUEEN**, and her foal. A stallion's lead mare is his favorite and is generally second in command. If the stallion is separated from the herd, she will take on leadership.*

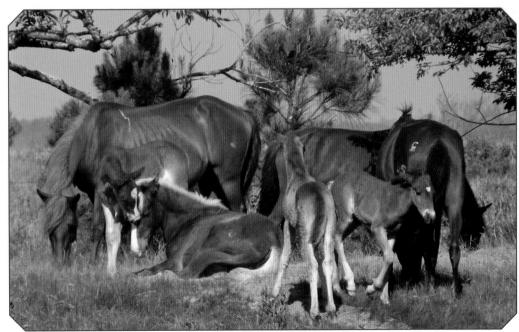

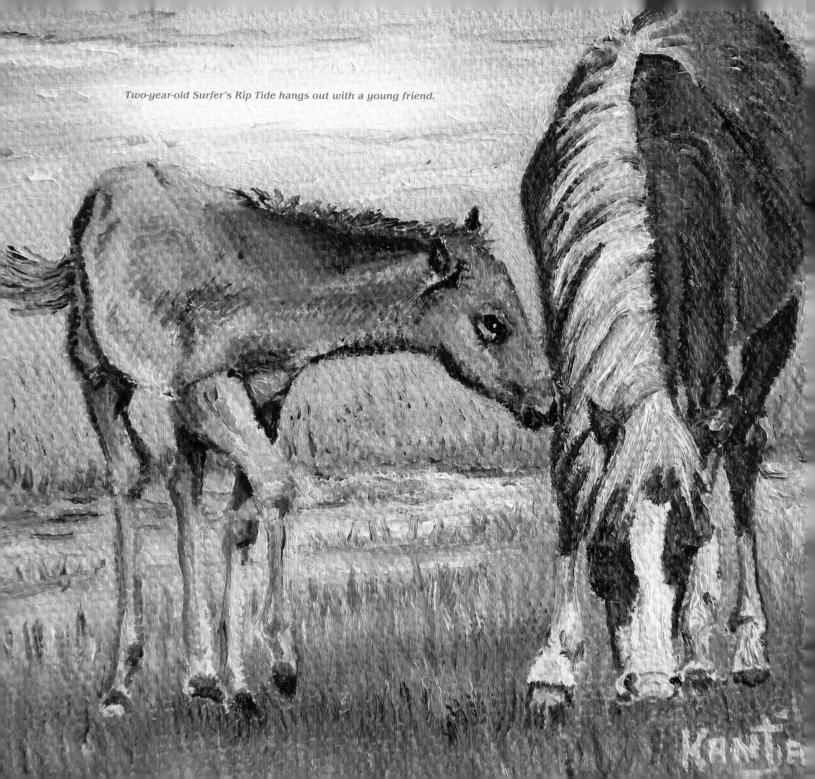

Two-year-old Surfer's Rip Tide hangs out with a young friend.

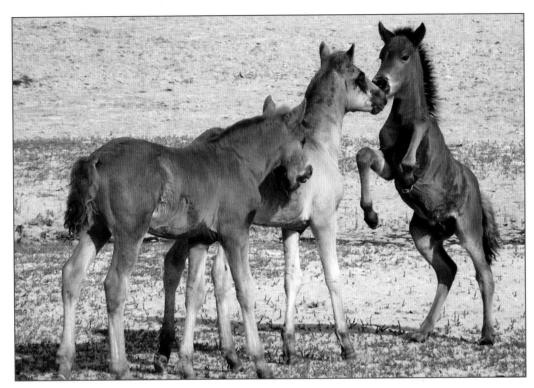

When foals get together, they play like children.

This photo of two foals grazing together shows the environment during a typical summer on Assateague Island. The marshes and inlets are green with grasses and foliage. The water at high tide fills in the channels and teems with life beneath the blue.

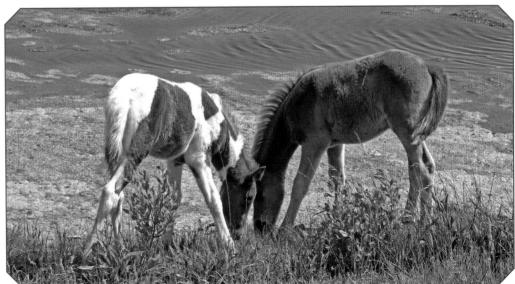

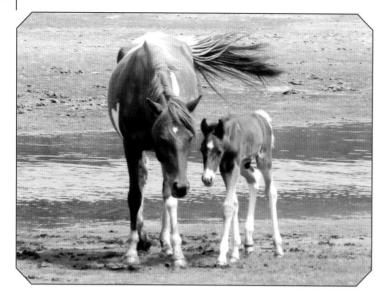

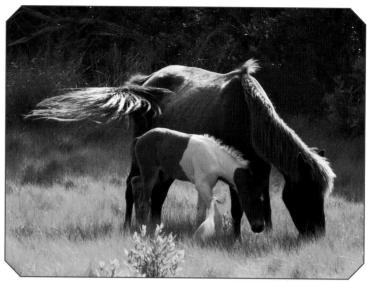

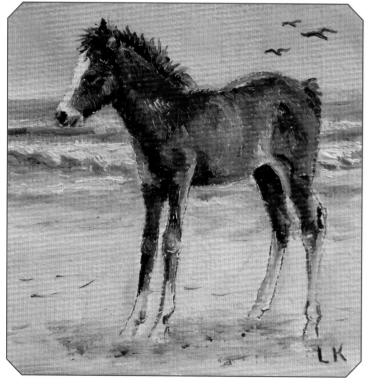

TOP LEFT:

The mare **DUCKIE** pauses with her leggy 2010 foal. She was a 2006 buyback filly.

TOP RIGHT:

A mare's powerful tail swishes to defend herself and her foal from the constant barrage of bugs. Horse flies and mosquitoes are plentiful in wetland environments. This foal stays close to his mother, **NOAH'S SHADOW**, depending on her to sweep away flies his short and curly tail can't reach. The pair is lucky to have an egret friend close by to eat some of the bugs.

BOTTOM LEFT:

Black, as well as black and white, foals often bring high dollar amounts at the Pony Penning auction. A favorite rescue story about a black and white mare was shared by the late Donald Leonard of Chincoteague: One harsh winter a black and white mare was found frozen in a freshwater pond on Assateague. When Leonard and his friend, Asa Hicks, dragged the pony out of the water to bury her, they found she had a heartbeat. They rushed the mare over the bridge to the Chincoteague Fire Department. As she warmed, the mare they named **ICY** gradually awoke and began to munch on hay, but she did not stand. A veterinarian told the firemen the mare would die if they couldn't get her to stand to get her circulation going. The ingenious firemen wrapped a canvas band around the pony and hooked a rope to the band. They threw the rope over rafters and hoisted her up. They tied the rope so she was suspended, hooves just touching the ground. Gradually she gained use of her legs. In the spring, just before they released her, Icy gave the firemen a surprise — a coal black colt was born in the firehouse. They named him Little Icicle.

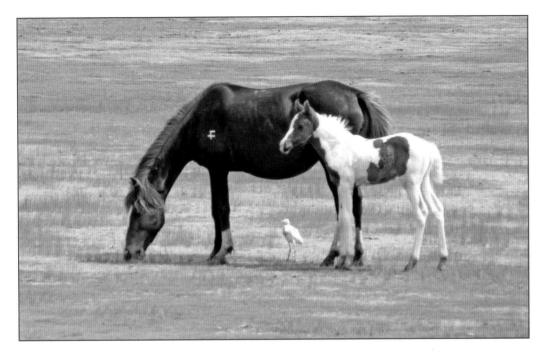

This mare is Surfer Dude's daughter and her name is **SURFER DUDE'S GIDGET**. Here, she and her buyback filly, **GIDGET'S BEACH BABY**, are accompanied by a bug-eating egret.

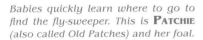

Babies quickly learn where to go to find the fly-sweeper. This is **PATCHIE** (also called Old Patches) and her foal.

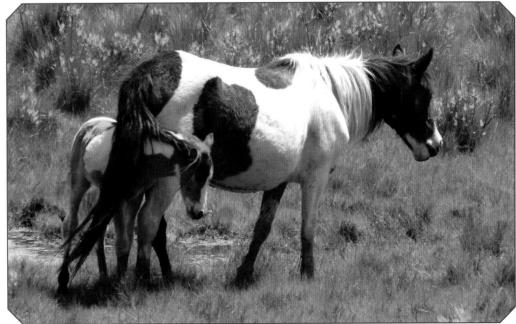

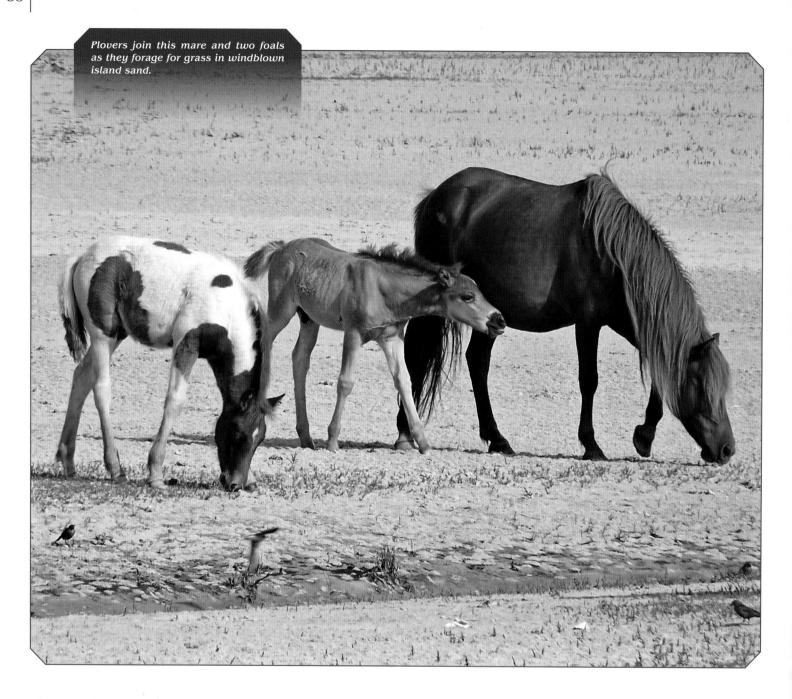

Plovers join this mare and two foals as they forage for grass in windblown island sand.

*This painting of the mare **LILY PAD** and her foal show the chestnut and white pinto color pattern so prevalent in the island herds.*

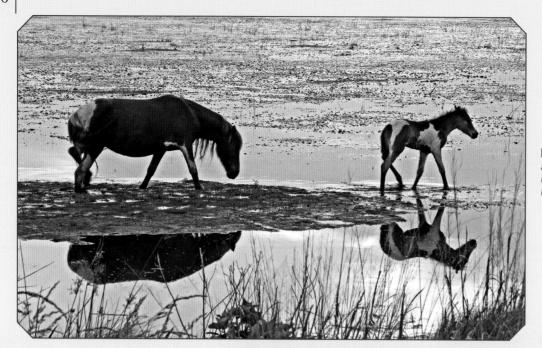

PAINT BY COLOR *(nicknamed Paint Butt) and a herd mate's 2009 foal wander through the marshes, duplicates of themselves reflected in the water.*

A mare and her tricolor foal forage in the marsh.

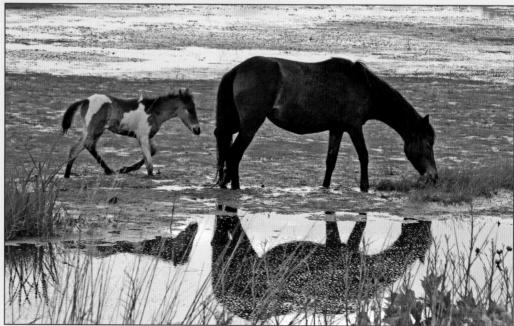

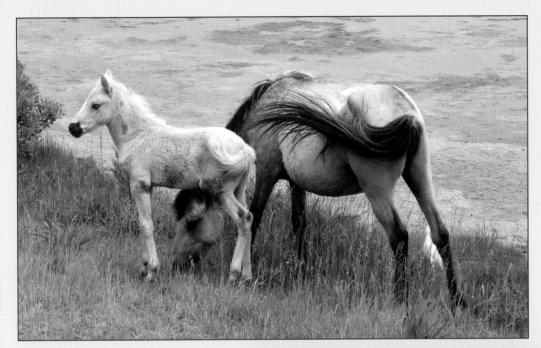

LANDRIE'S GEORGIA PEACH *(nicknamed Peach) and her 2009 foal.*

This is the 2010 foal of Landrie's Georgia Peach. The same mare can produce many different colors and patterns with the same sire.

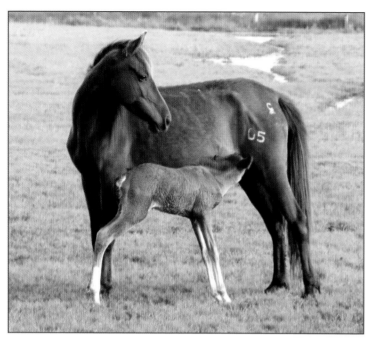

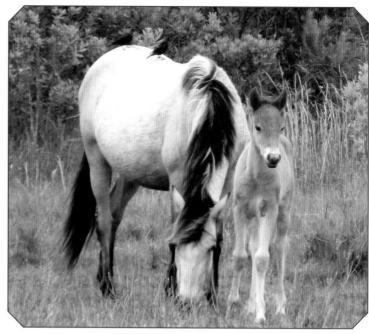

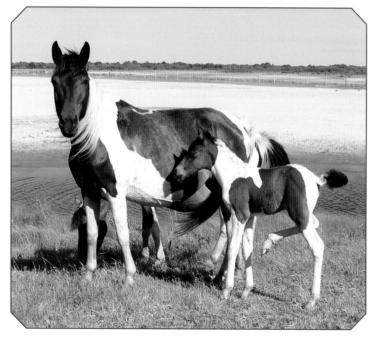

TOP LEFT:
The mare **ELUSIVE STAR** keeps watch as her foal nurses.

TOP RIGHT:
This striking buckskin mare is **LANDRIE'S GEORGIA PEACH** (nicknamed Peach). The mare was the buyback of Deb Folsom and was named after her daughter, Landrie. The cowbirds on the mare's back are looking for a meal of their own, plucking pesky mosquitoes and flying insects, giving relief to the mare. Cowbirds got their name because they were frequently observed gathering to eat bugs stirred up by cattle. In order for the birds to remain mobile and stay with the herd, they learned to lay their eggs in the nests of other birds. The cowbird watches for a host to lay a nest of eggs and then moves in to add her eggs to the clutch. If the cowbird egg is pushed out of the nest, the enraged cowbird often destroys the host's eggs, too. The female cowbird often checks in on the nest and her baby birds.

BOTTOM LEFT:
This mare is named **SEASIDE WANDERER**. Long-ago, she was nicknamed "Bird Poop" by members of the Buyback Babes who thought she had the same on her back. When rain didn't wash it away, they realized it was a marking!

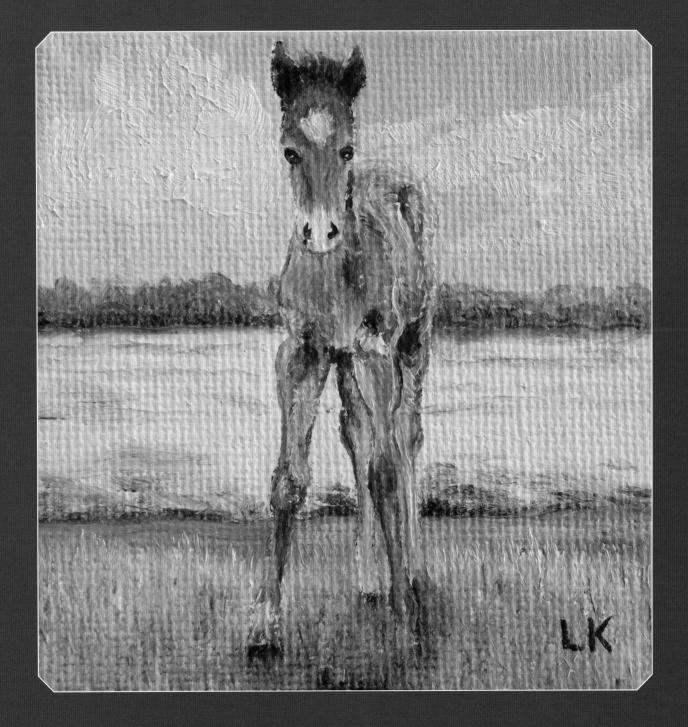

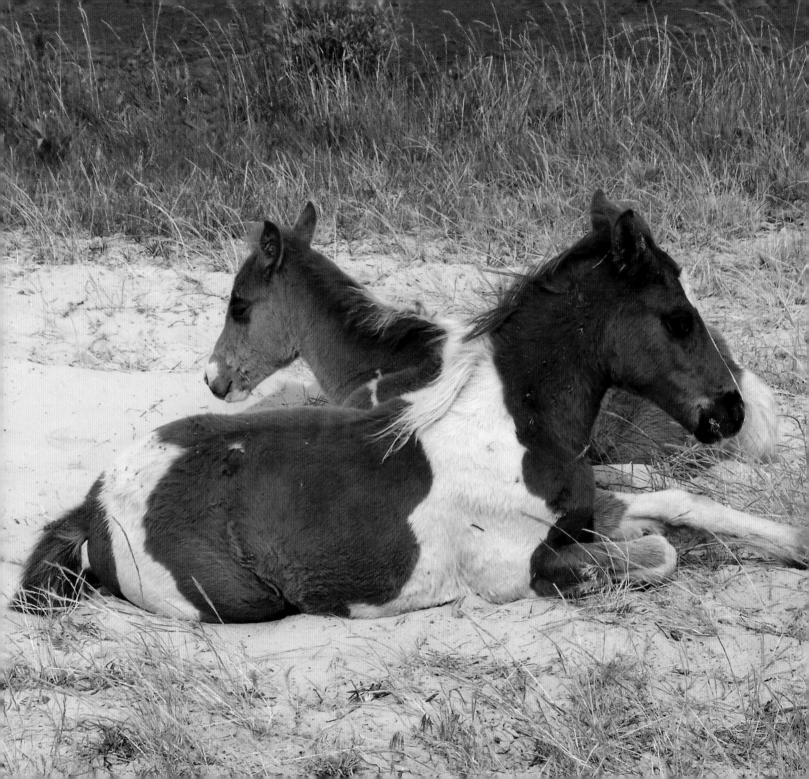

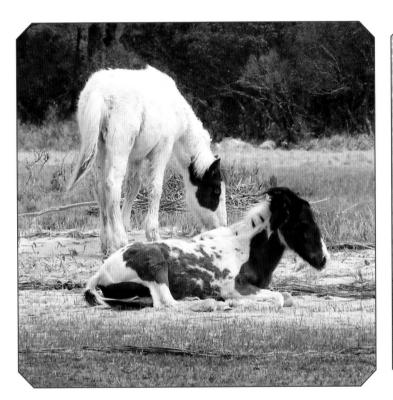

*The pony resting in the sand is **Freckles**. This blue-eyed buyback mare was purchased and named by the Buyback Babes, who liked her freckled coat.*

***Poco Latte** and her foal graze by the water's edge.*

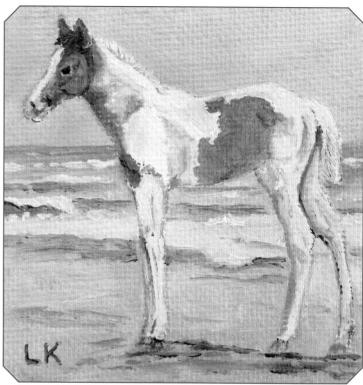

This beautiful blue-eyed foal is by the mare affectionately known as Got Milk and the stallion, Surfer Dude. Her mom, Got Milk, was named for her white nose that looks as if she'd just lifted it out of a glass of milk. This foal sold for $900 at the 2010 Pony Penning auction.

BEACH BABY as a foal. She was sired by North Star and born very light in color. She darkened as she grew into a yearling.

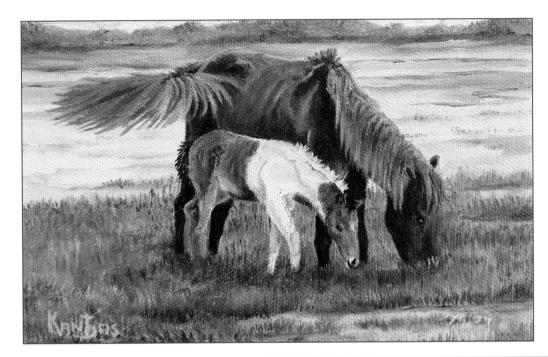

Water is plentiful on Assateague Island. It helps the grasses grow to nourish the ponies, but it also brings more mosquitoes to irritate the ponies. Long sweeping tails work extra hours to keep the bugs at bay. This is **NOAH'S SHADOW** and foal.

This is the mare **SHYANNE**, nicknamed "Half and Half."

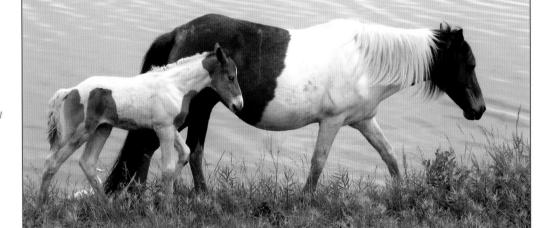

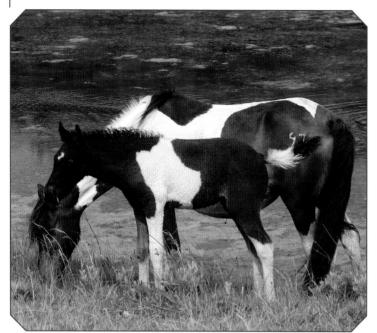

This is **DREAM CATCHER** and her 2008 filly, **DREAM DANCER**, who was purchased by the Buyback Babes. One of their members was fighting cancer. She wanted the group to purchase a black and white pinto buyback foal, but couldn't decide between Dream Dancer and another (later named Angel Wings) so the group bought both! Dream Dancer still has a curly coat in the winter when her hair grows thick. She has one of the curliest coats seen on the island.

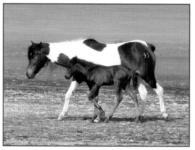

Here is **DREAM CATCHER** with one of her foals.

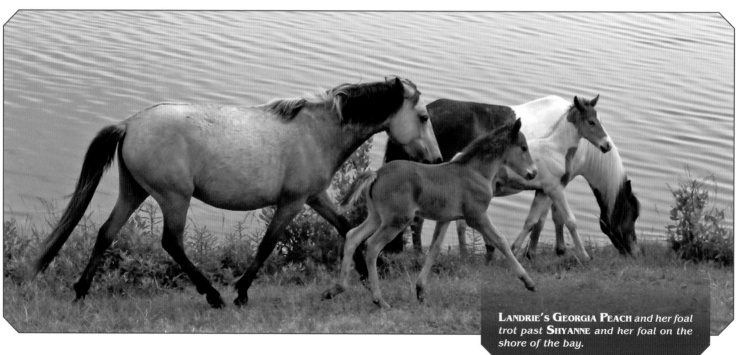

LANDRIE'S GEORGIA PEACH and her foal trot past **SHYANNE** and her foal on the shore of the bay.

*The curly-coated **DREAM DANCER** grazes on Assateague. The curly coat on Dream Dancer is foal coat, the thick hair they get just after birth and during their first winter. It has begun to shed from her face.*

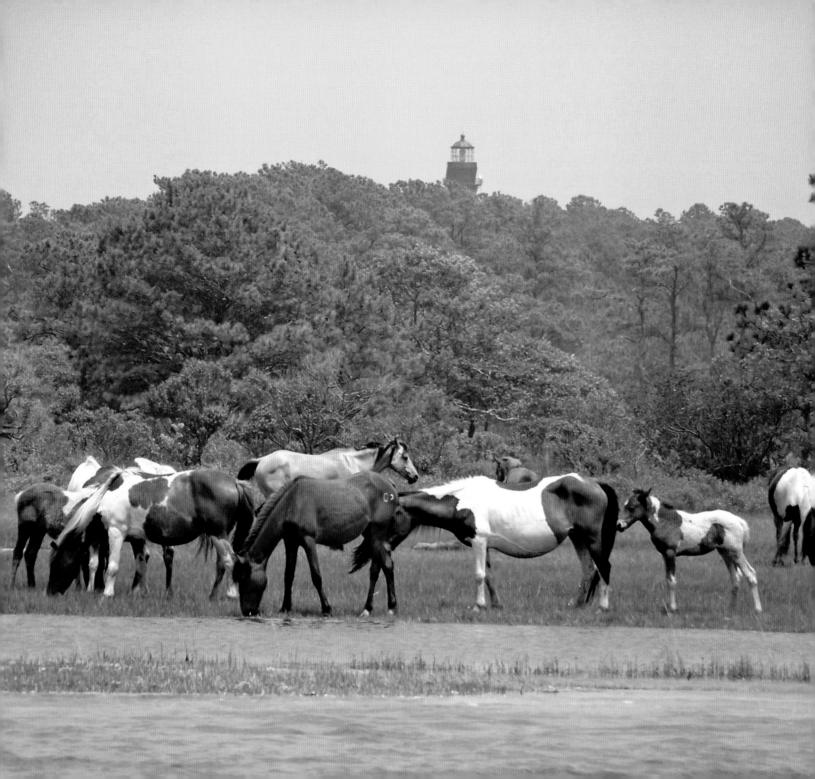

OPPOSITE:
*This beautiful photo of **YANKEE SPIRIT** (also known as Spirit and sometimes Spirit of Assateague) and his herd was taken from a tour boat. The famous Assateague Lighthouse can be seen in the background. Tour boats are one of the best ways to catch pictures of the ponies on the water. The bus that goes to the north side of the island also offers many opportunities to photograph the ponies.*

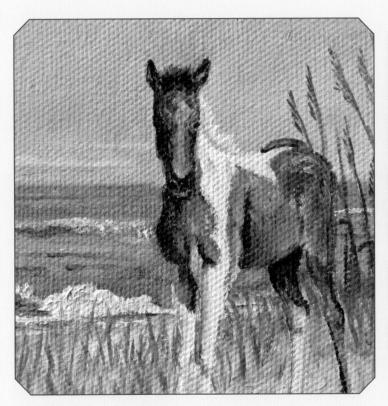

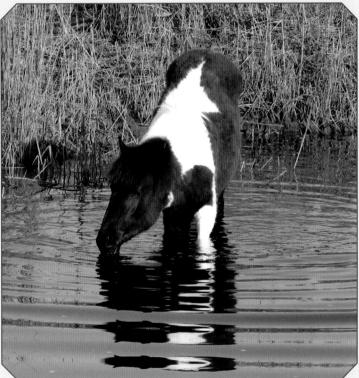

*This filly, named **ANGEL WINGS**, was purchased by the Buyback Babes in 2008.*

***ANGEL WINGS** wades into the water to drink.*

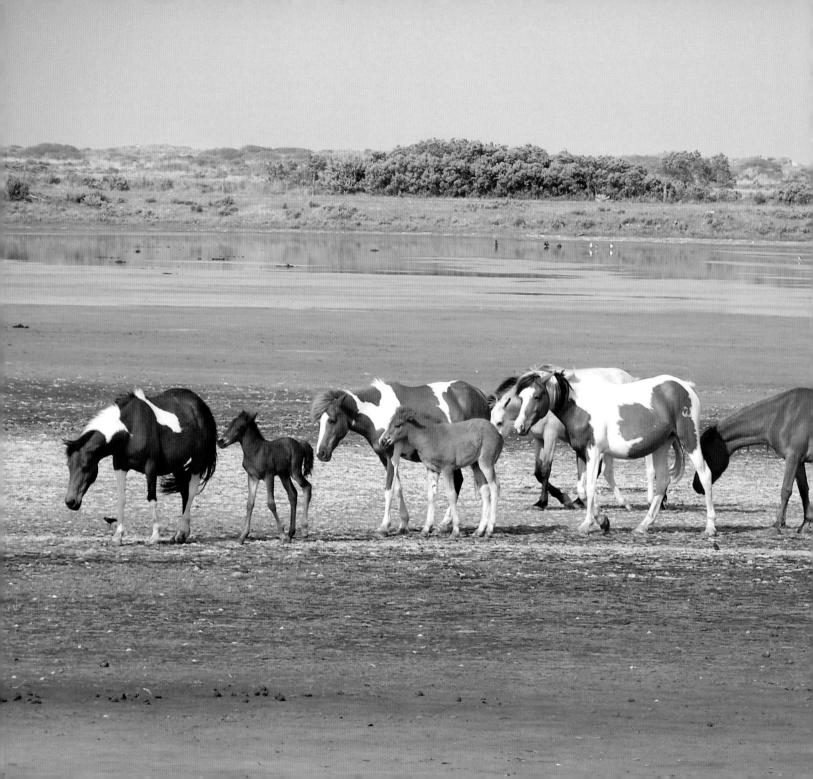

*A herd crosses the marsh flats. The mare **E.T.** can be seen in the center of the herd, identified by the white marking on her side shaped like a long finger. In the background are the dunes that precede the Atlantic Ocean.*

This is the mare **HIGH FIVE** and her 2010 foal. Many on the island know her by her nickname, "Cindy." Her foal was sired by the stallion Surfer Dude.

HIGH FIVE (nicknamed "Cindy") and her foal doze in the protection of laurel bushes and loblolly pines.

This is High Five's 2010 foal getting a lesson from another mare, **BUTTERFLY KISSES**. Foals often pester other mares in the herd. On this day Butterfly Kisses had enough of the foal's shenanigans and offers a warning nip. In the background, **HIGH FIVE**, dozes under a shady tree.

High Five's foal has settled down to rest next to the mare, Butterfly Kisses. The mare was owned by the family of Suzanne Craig, a beloved Buyback Babe member who lost her life to cancer. Now, the mare passes her love on to another mare's foal.

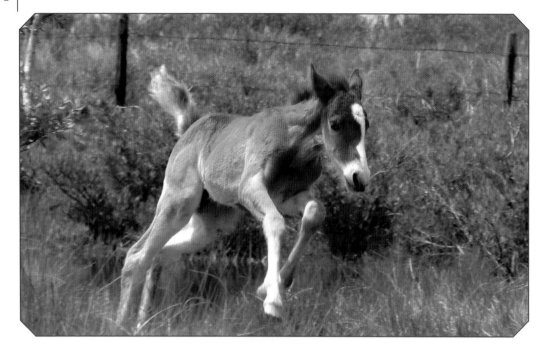

*This pretty blue-eyed foal is Surf Queen's 2010 baby. Surf Queen is Surfer Dude's lead mare. The foal was named **MADDOX** by Jeff Clark who bought him at Pony Penning. Maddox is the name of the road that runs from the bridge onto Chincoteague, down a main shopping strip, and across the bridge onto Assateague Island, leading to the beach and the ponies.*

*Miracle Man's herd stops for a rest and the foal's nap. **MIRACLE MAN** is second from the left, next to **BINKEY'S BREEZE** in the center. **LADY HOOK** is off to the left. To the far right is **SEASIDE WANDERER** (known as Bird Poop).*

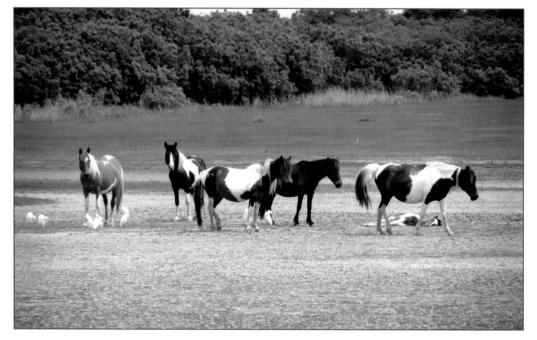

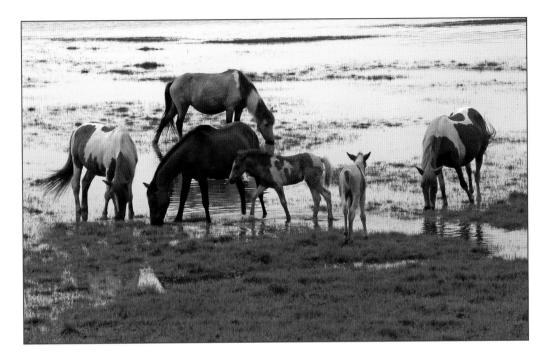

SPIRIT *(left) and his mares graze in the tidal marsh. Next to Spirit, the bay mare is* **MYSTERY** *(with her foal), Ramblin' Ruby's foal, and then* **RAMBLIN' RUBY**. *In the back is* **HONEY BEE**.

For quite some time this group of yearling buybacks ran together on Assateague. The pinto filly in front is **AMERICAN GIRL**. *She's followed by the palomino named* **CHIEF GOLDEN EAGLE** *and* **DREAM DANCER** *on the right. Ken's sorrel body and blaze are in the background.*

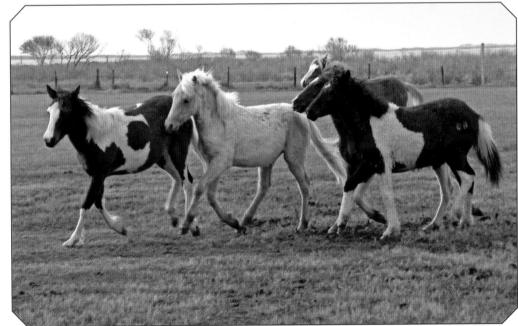

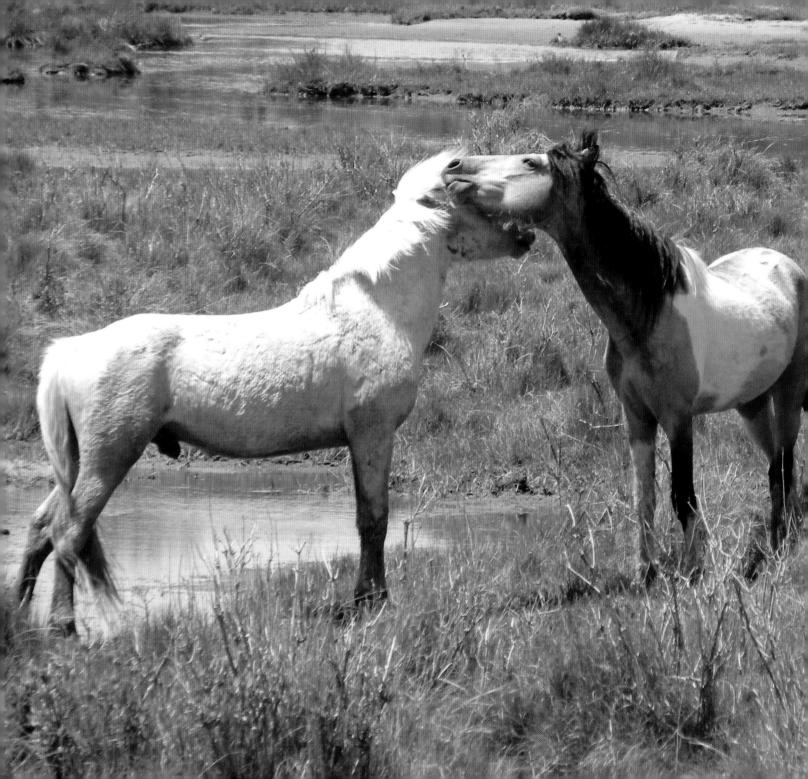

OPPOSITE:
*Two young stallions rub heads, which sometimes leads to a fight. On the left is **CHIEF** and **LITTLE TORNADO** is on the right. Both are buyback colts. Those who purchase buyback foals often have personal reasons for the names they give them. Joanne Rome and her mom purchased Chief. She said Chief's full name is Chief Golden Eagle. Rome said her family always had horses, many of them palominos, like Chief. "By the time we bought Chief all our palomino horses had died of old age," she said. "My stepdad always collected eagles. We try to use something Indian (when we name) our buybacks. My mom loves American Indians and my grandpa's side of the family is American Indian. We used Golden for his coloring and because one of my sister's favorite palominos was (named) Golda. I hope he is a mighty warrior and produces many wonderful additions to the Chincoteague herd."*

CHIEF GOLDEN EAGLE and **DREAM DANCER** are *reflected in the waters of Assateague Island.*

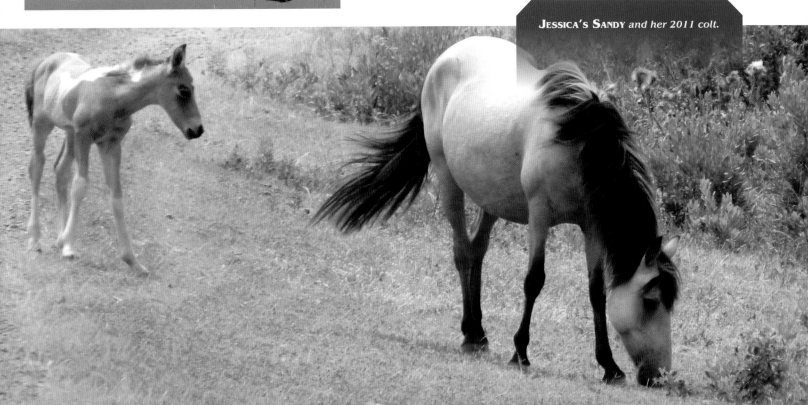

JESSICA'S SANDY and her 2011 colt.

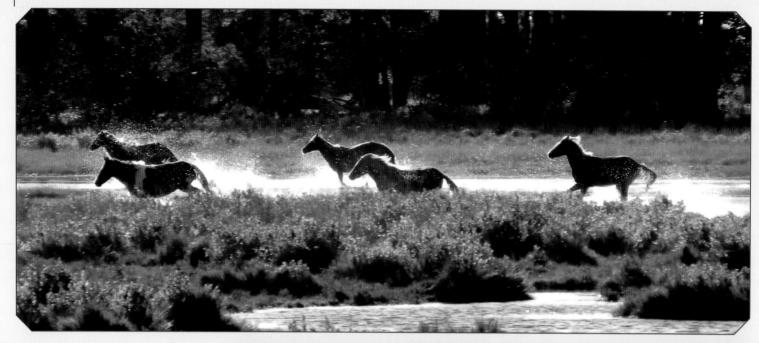

Ponies race before a backdrop of loblolly pine trees. The greenery in the front is called salicornia, also known as glasswort. Salicornia is one of the few plants that can actually tolerate immersion in saltwater, making it a resilient plant for this salty environment. It is also edible to both animals and humans. In the fall it gets a pinkish hue, adding color to Assateague meadows.

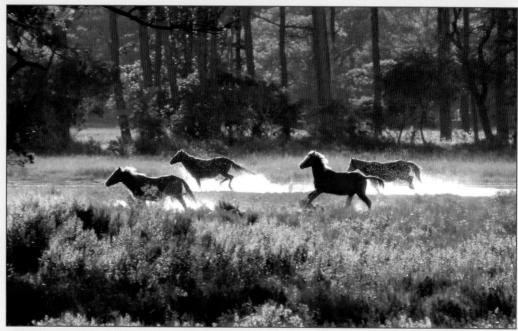

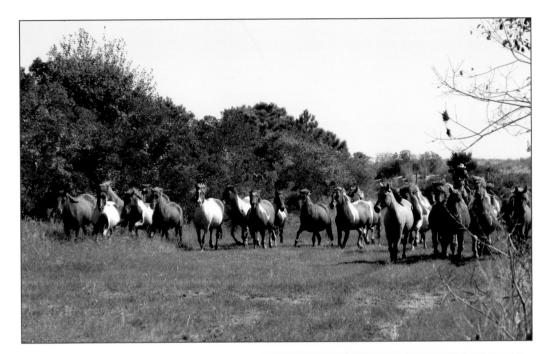

Ponies on the northern end of the preserve are herded to the corrals by saltwater cowboys on horseback. Here they will be checked by a veterinarian and then wait to be paraded from the northern pens to the southern pens as part of Pony Penning week.

Running together at roundup time are mares **RAMBLIN' RUBY** (in front) and **CARNIVAL LADY**, also known as Magnum's Mom, in the middle. They're followed by the stallion **YANKEE SPIRIT**, often called Spirit of Assateague by the group known as the Buyback Babes.

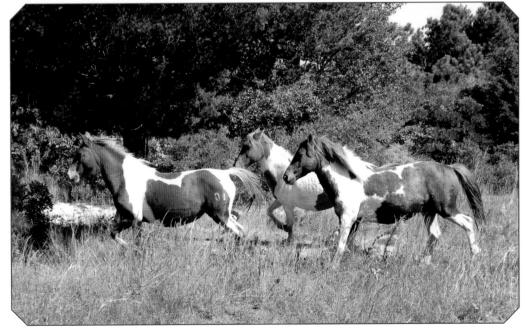

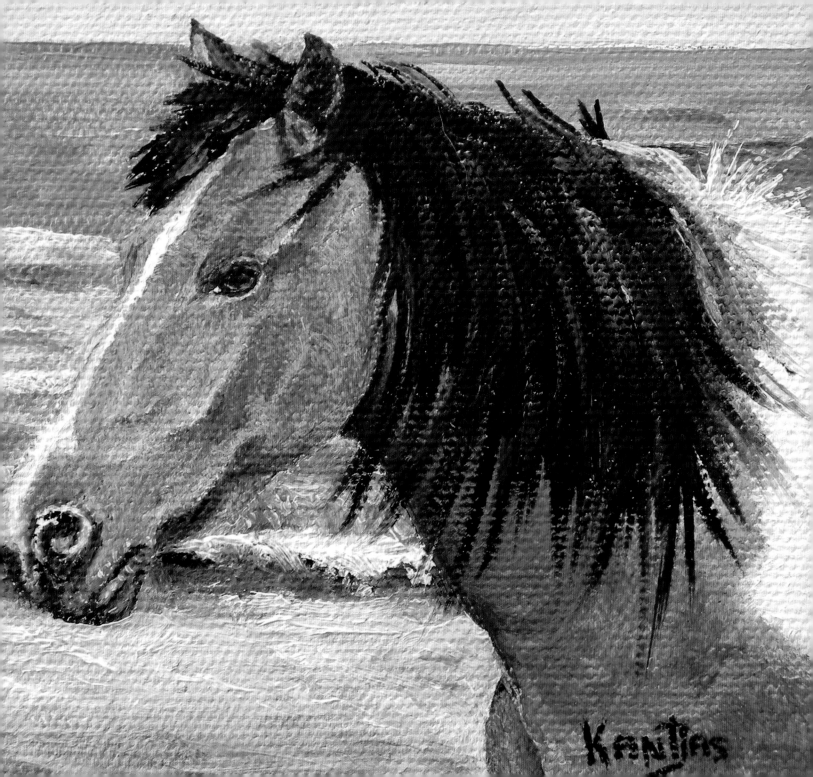

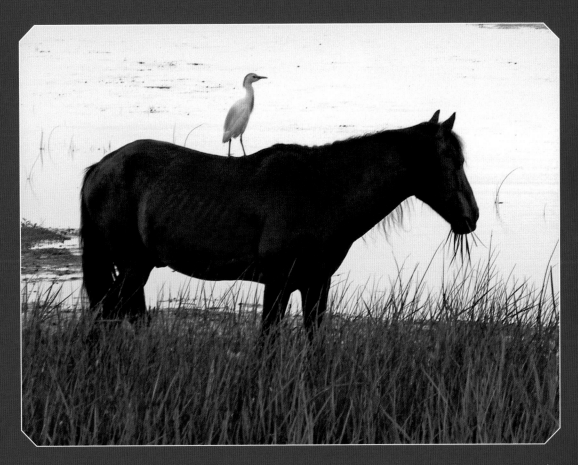

This stallion was returned by a buyer and turned out on the island in 2008. He aggressively battled to claim mares of his own. At Pony Penning he was pursued by standing herd stallions, but he did not back down. He was named CHAOS. The pony committee worried that he would seriously hurt one of their valuable sires and decided to sell him. Lara Cornell purchased him for her growing Chincoteague Pony herd and took him home to Maryland where he quickly adjusted to his mares and thrived. Lara said he was a wonderful stallion, but he lived less than a year, passing from a burst aneurysm during the following winter. One of the mares on the island had a foal by Chaos the following year. The buyback foal, named Catwalk Chaos, will carry on the stallion's bloodline.

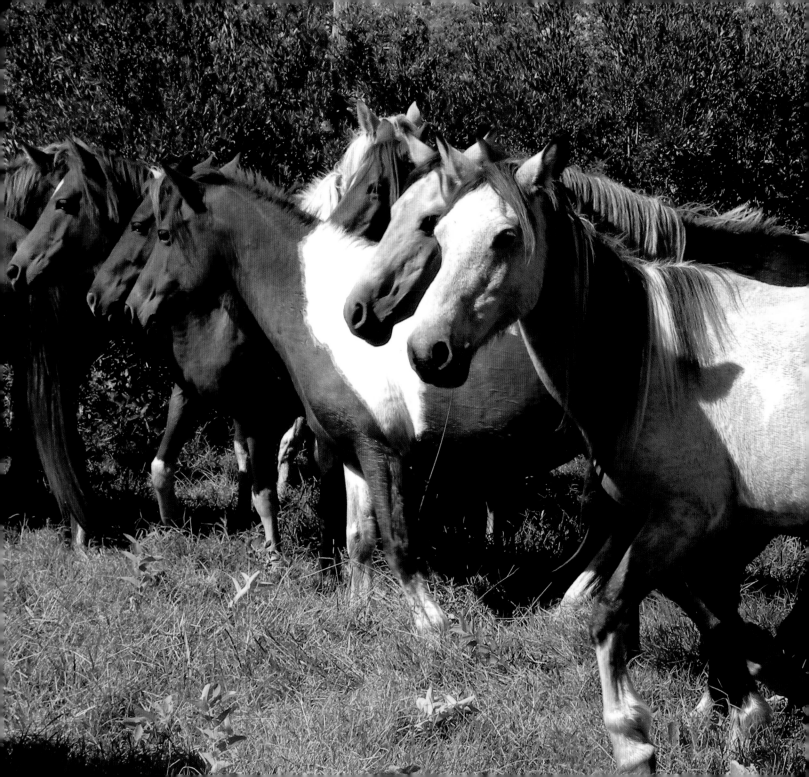

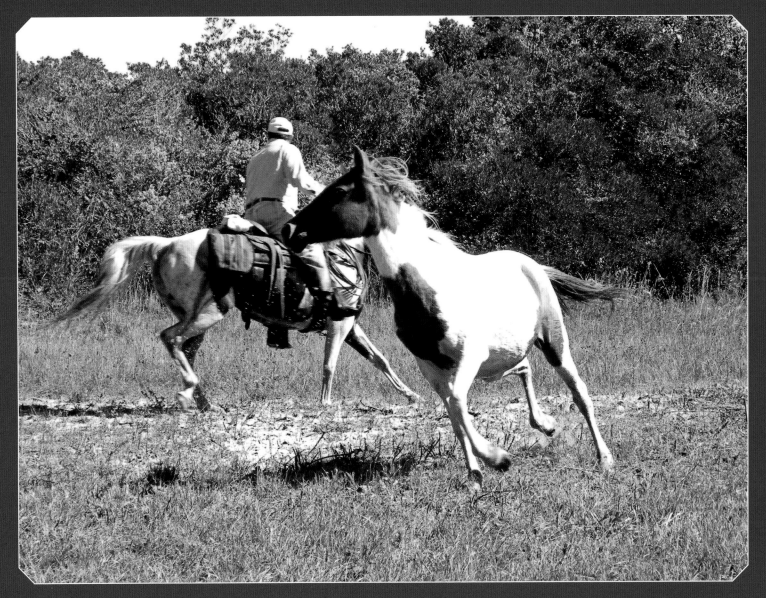

*The mare **CARNIVAL LADY** (nicknamed Magnum's Mom) expertly dodges a saltwater cowboy. He will have to circle back for her.*

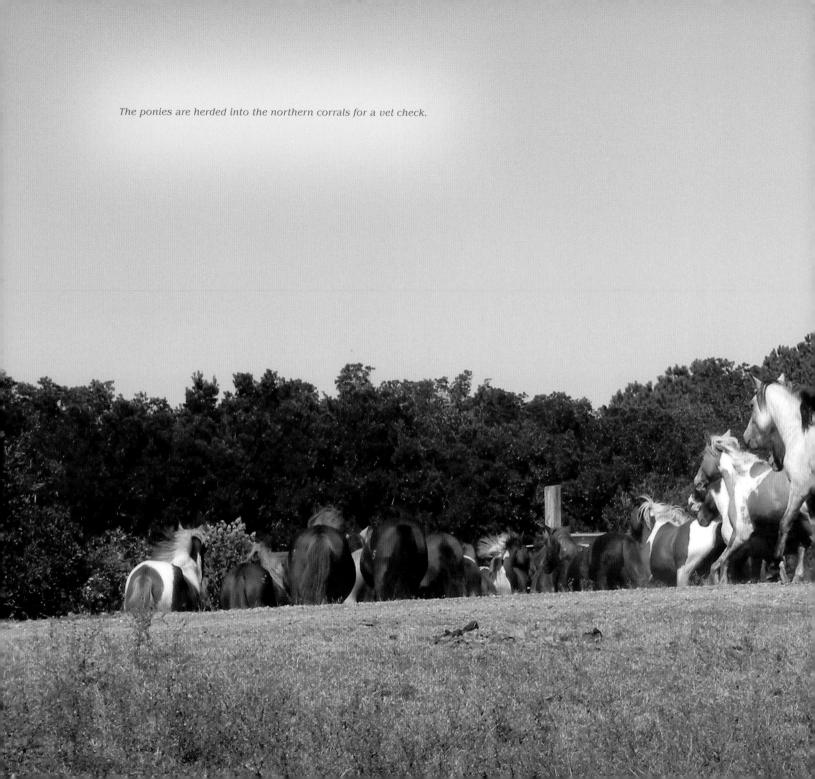

The ponies are herded into the northern corrals for a vet check.

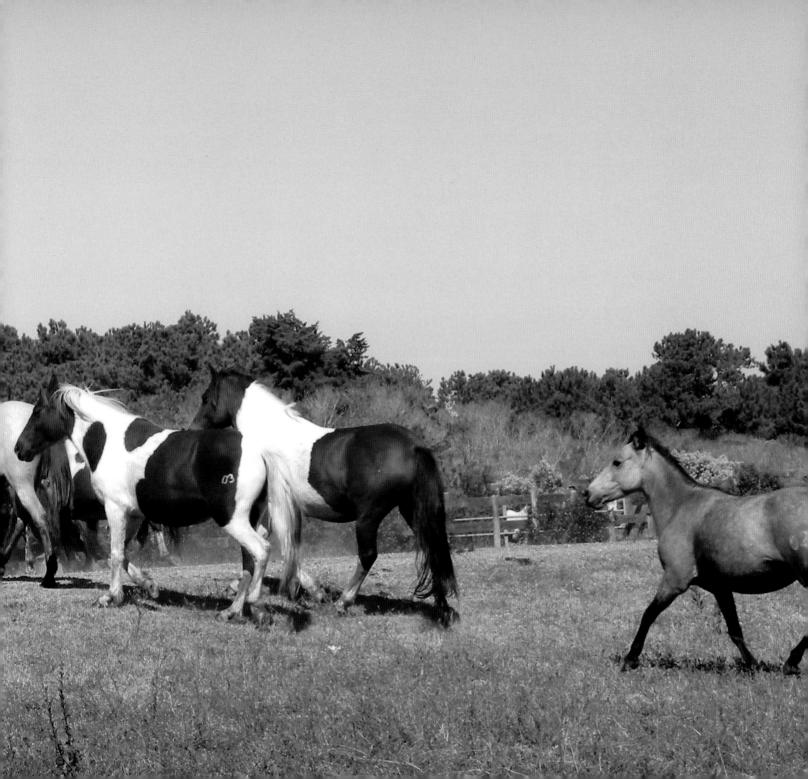

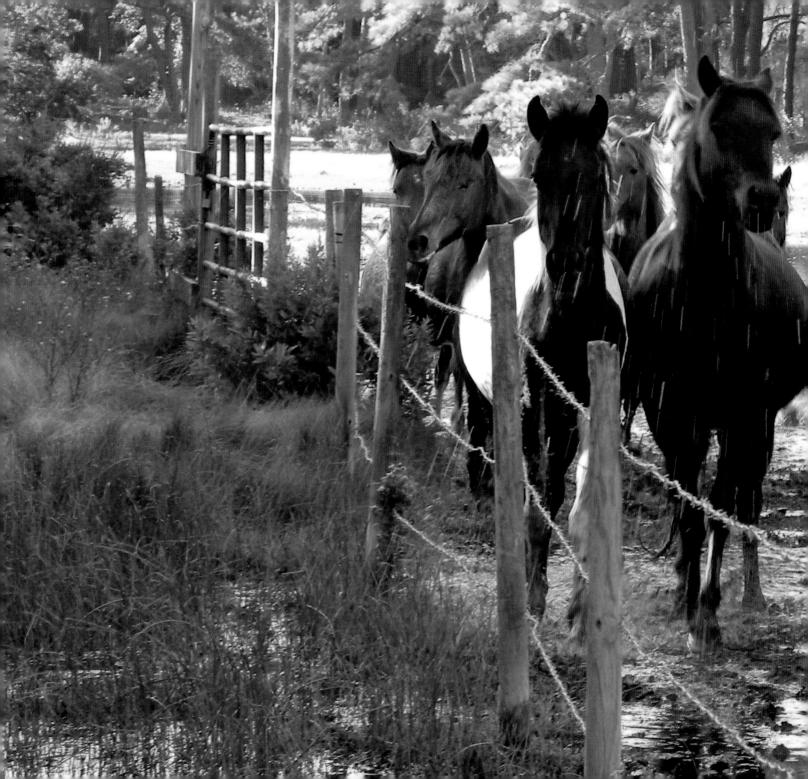

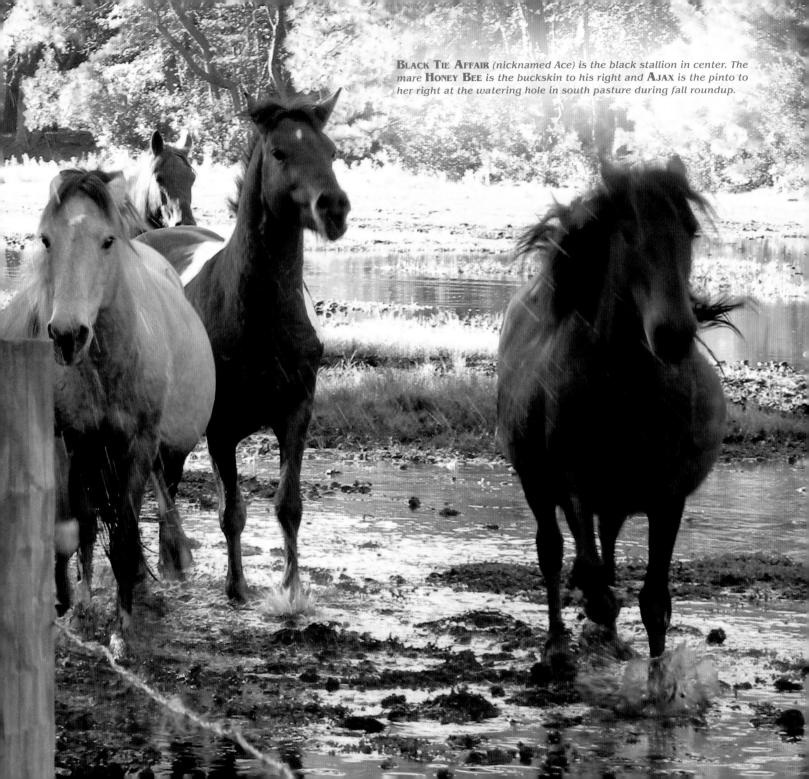

BLACK TIE AFFAIR *(nicknamed Ace) is the black stallion in center. The mare* HONEY BEE *is the buckskin to his right and* AJAX *is the pinto to her right at the watering hole in south pasture during fall roundup.*

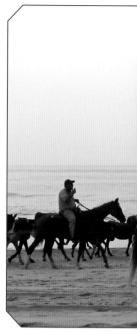

The ponies are trotted through the south watering hole and on to the southern holding pens. On the Monday of Pony Penning the herds penned on the northern end will be brought down to join them.

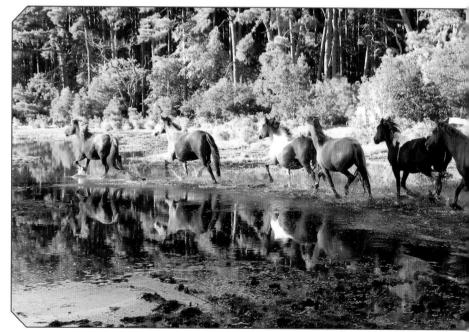

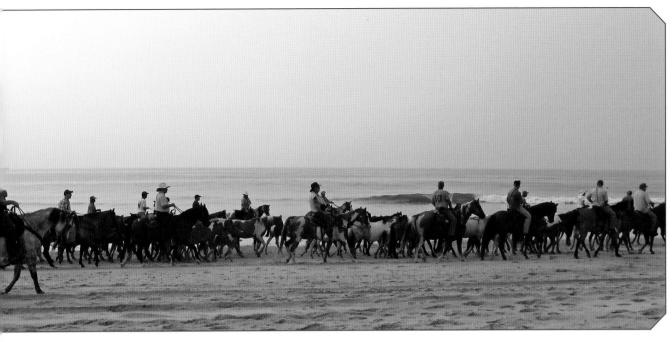

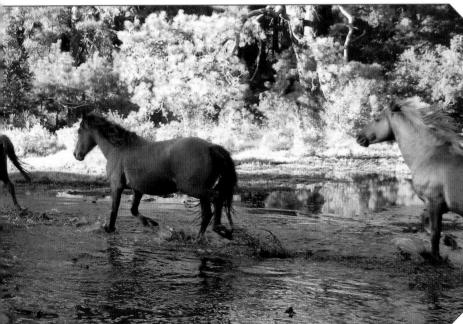

On Monday of Pony Penning week the northern herds are driven down the coastline against a backdrop of ocean and rising sun. Crowds gather to watch as they are moved to join the southern herds in the south corrals.

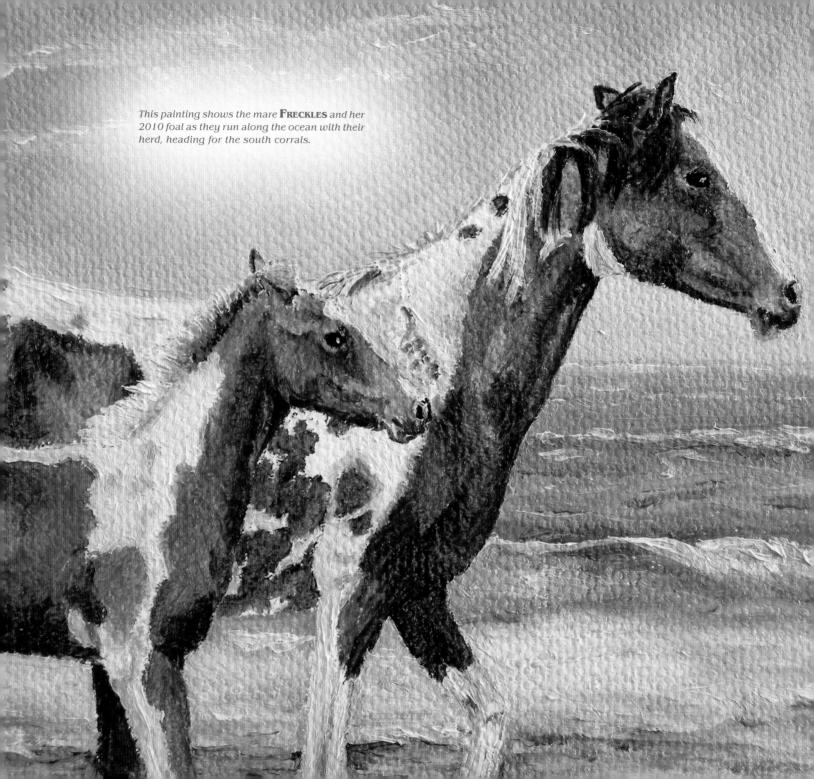

This painting shows the mare **Freckles** and her 2010 foal as they run along the ocean with their herd, heading for the south corrals.

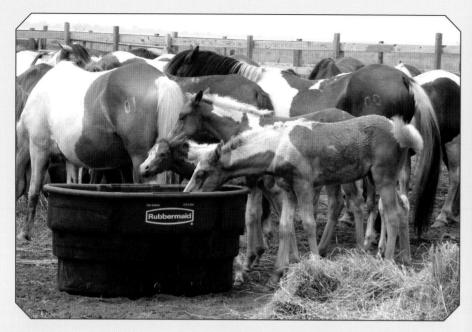

The Chincoteague Volunteer Fire Company provides hay and water for the ponies in the pens at Pony Penning. Visitors come to south corrals to see the ponies and pick out the ones they want to bid on from Monday of Pony Penning week until they swim on Wednesday.

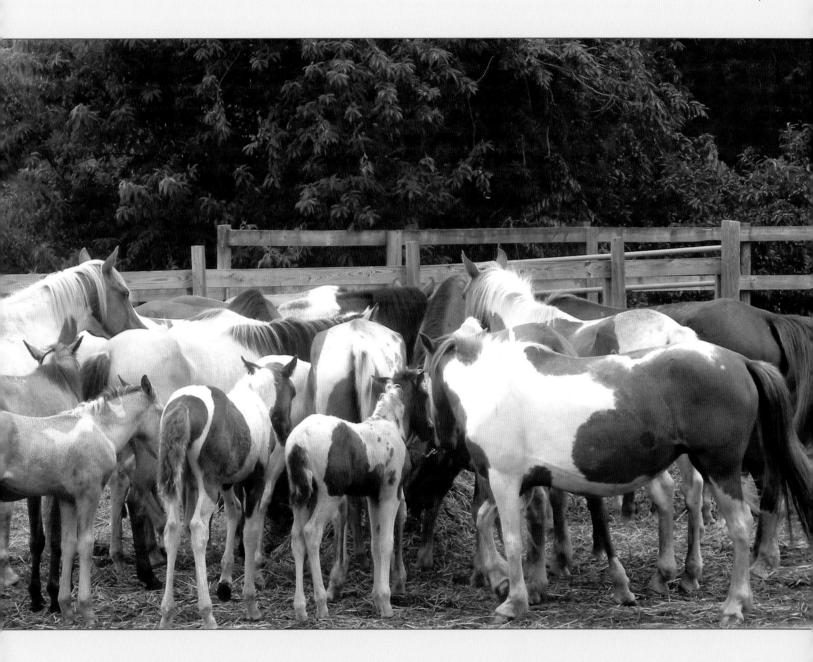

On swim day an orange plume of smoke shot into the air signals the start of the swim at slack tide — that time between high and low tide when the water is not moving. As many as 50,000 people gather at Memorial Park on Chincoteague to watch the ponies swim between the boats from Assateague to Chincoteague. When the shot goes off, cheers go up, boats' horns blow, and waders move into deeper water to await the ponies that will pass by.

Cowboys on horseback swim alongside the herds as they move past cheering crowds at Tom's Cove Campground. The herds generally leave from a marshy point farther north, but in 2011, after hours of waiting, they broke loose and entered the water closer to Tom's Cove.

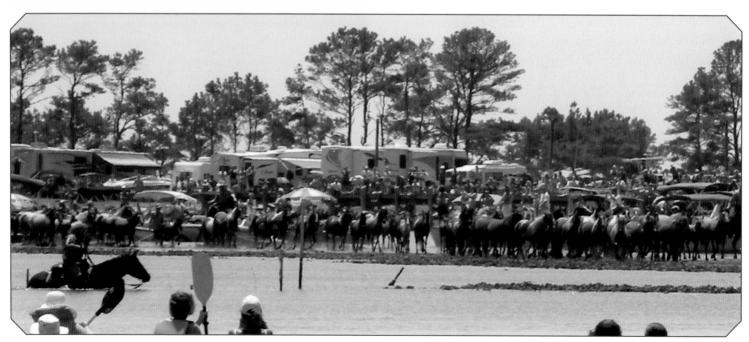

Top: The herd heads for the shoreline at Memorial Park on Chincoteague Island. Bottom: The ponies come ashore.

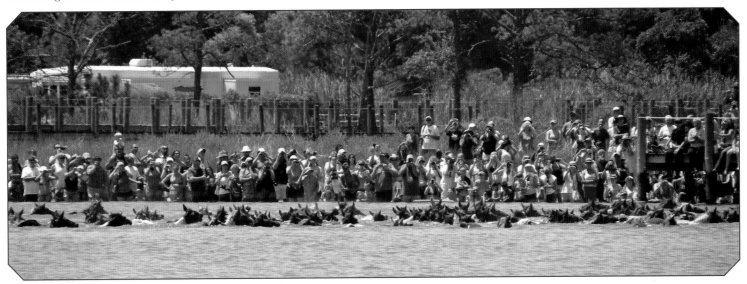

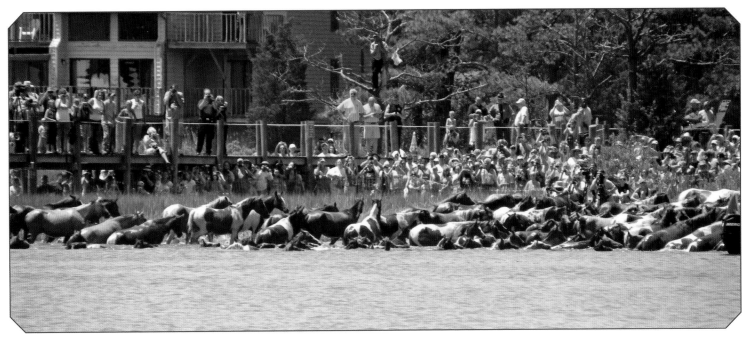

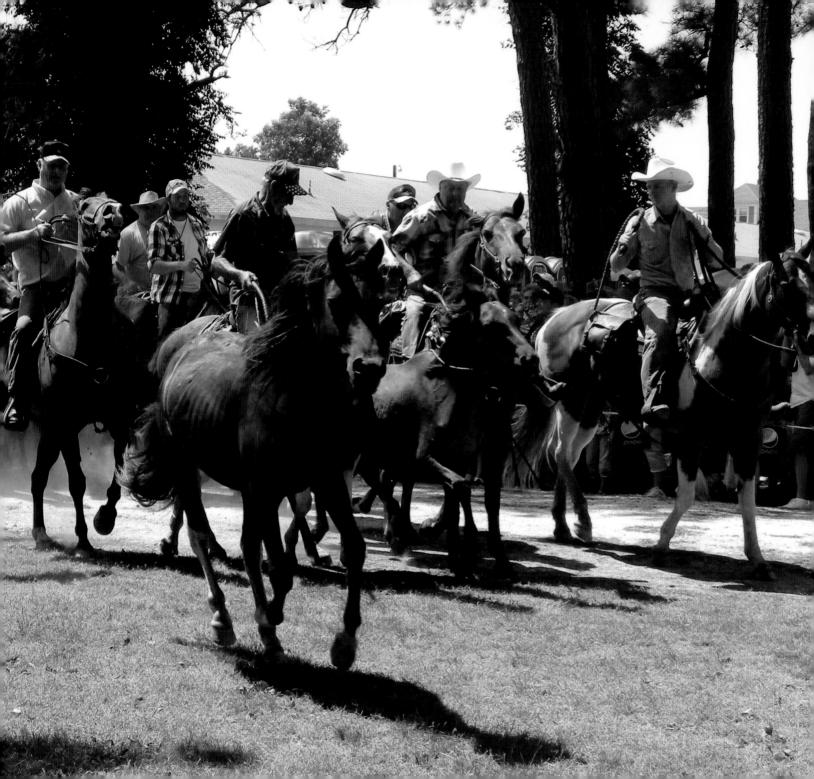

OPPOSITE:
After the ponies are rested at Memorial Park on Chincoteague they are herded down the roads and into carnival lane to their final destination in the pens on the carnival grounds. Here we see **BLACK TIE AFFAIR** *(nicknamed Ace) leading the ponies to the pens on the carnival grounds. He seemed to know where he was going.*

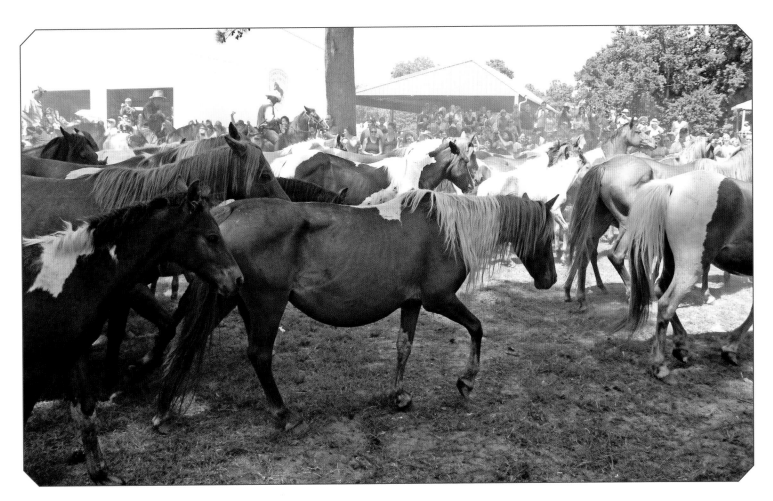

Saltwater cowboys on horseback bring the herds onto the carnival grounds.

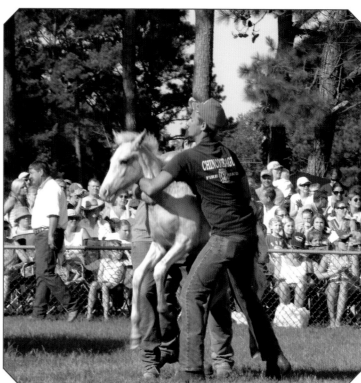

On Thursday morning the carnival grounds are packed with spectators. Some come to watch. Others come to buy! The foals are led out one by one and the bidding begins. This is Mystery's 2011 filly who was a buyback with the money designated as a donation to the Ronald McDonald House.

This colt out of Living Legend was sold to a Feather Fund recipient in 2011.

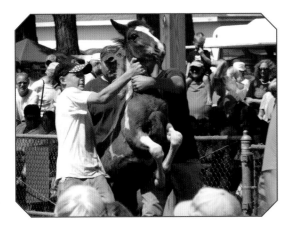

A foal in the auction ring goes up on his hind legs. This was foal number 45 in 2011. Foals are tagged with numbers for registration purposes.

After the auction, foals often whinny for their moms. This is Dream Catcher's foal. Some say it is cruel to separate them, but food sources on their island habitat can only support about 150 ponies, and continuing to nurse a foal is hard on a mare, especially since a new foal is often in utero. The young must be sold to ensure the survival of the herds.

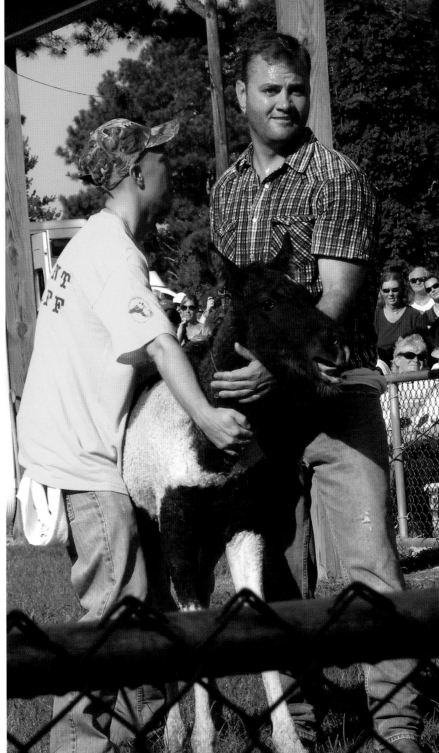

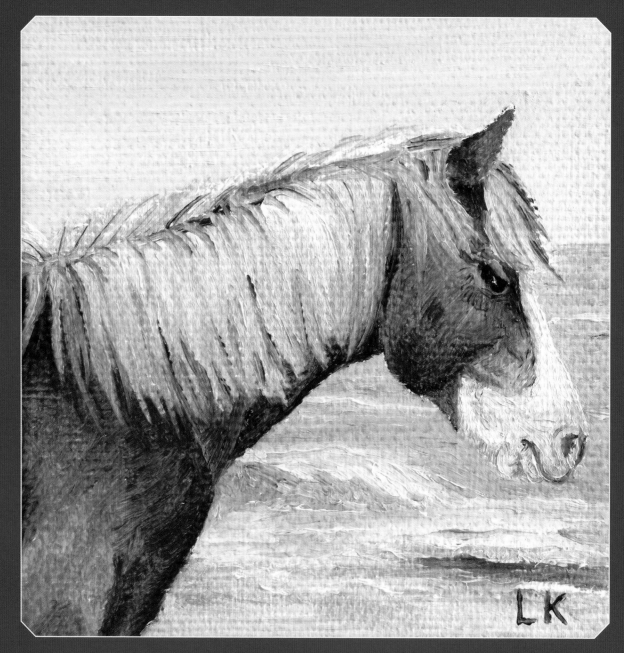

This is Surfer Dude's 2009 colt, **RIP TIDE.**

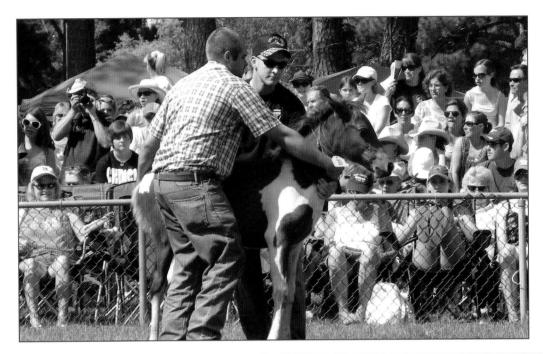

The crowd looks over foal number 30, a 2011 filly out of E.T., a buyback mare of Jean Bonde.

BEACH BABY, MILK DUD, *and (mare) Surfin' Scarlet's baby: Buyback foals and their dams as well as fall pickups are kept on the carnival grounds after the herds swim home, keeping them safe and well fed by the pony committee. They graze there long after Pony Penning has passed.*

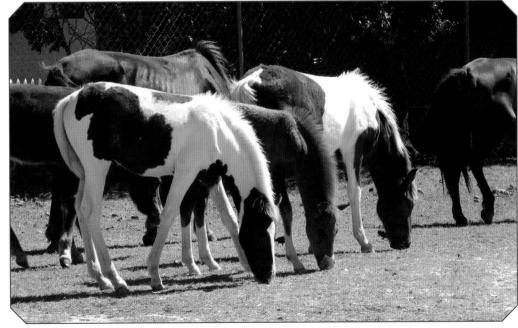

This buyback filly is **MOLLY'S ROSEBUD**, nicknamed "Rosie" by the Buyback Babes. She is also known as "Mini-Pot" because she looks like her dam, Merry Teapot's High Bid. The proceeds of this buyback went to the Hospice of the Eastern Shore.

The mare **SURFER DUDE'S GIDGET** grazes on the carnival ground next to her filly, **GIDGET'S BEACH BABY**, whose sire is North Star. Gidget was purchased by the Buyback Babes in 2002 and Beach Baby was purchased by them in 2010.

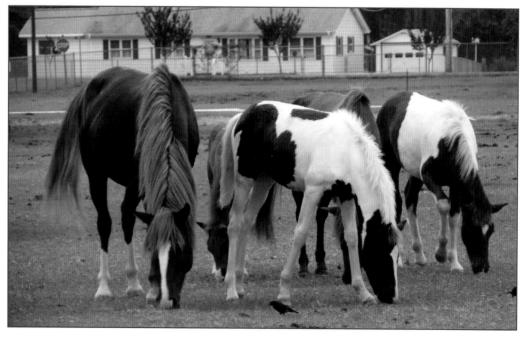

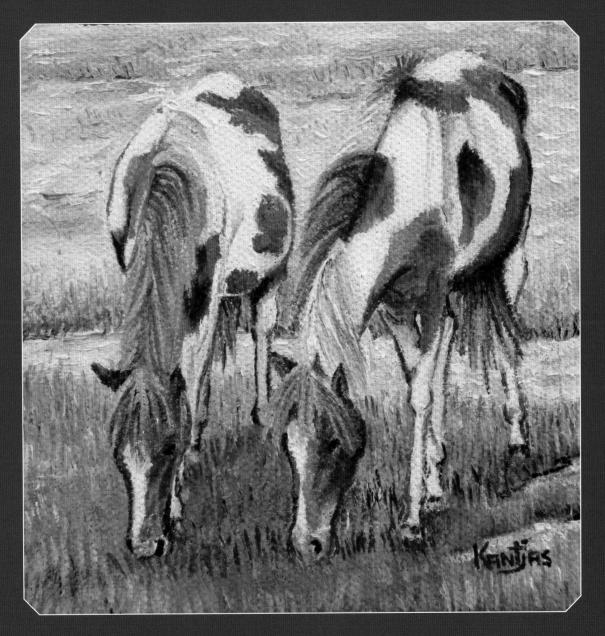

Buyback mom, Joanne Rome, said she and her mom Ginnie named this one **COURTNEY'S ISLAND DOVE***. She explained her reason, "The sire is Courtney's Boy, they are island ponies, and doves represent freedom. She is free to roam in the wild," said Rome. Here Dove (on the left) grazes with* **BUTTERFLY KISSES** *(on the right).*

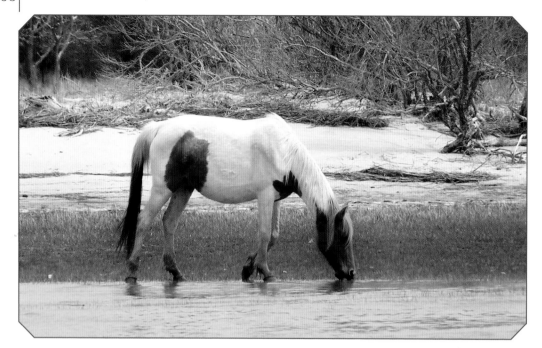

A mare named **CARNIVAL LADY**, *also called "Magnum's Mom," grazes on grassy stubble. Windblown sand often looks like snow.*

PAINT BY COLOR *(nicknamed Paint Butt) and* **LIL' TORNADO** *keep watch at the watering hole.*

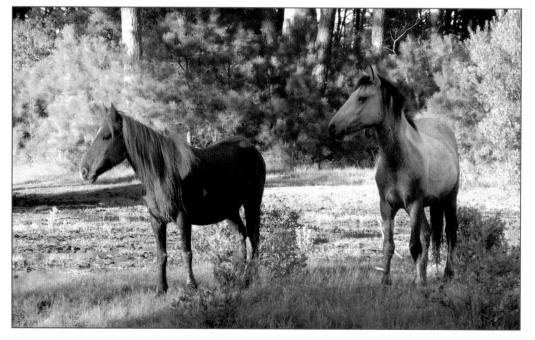

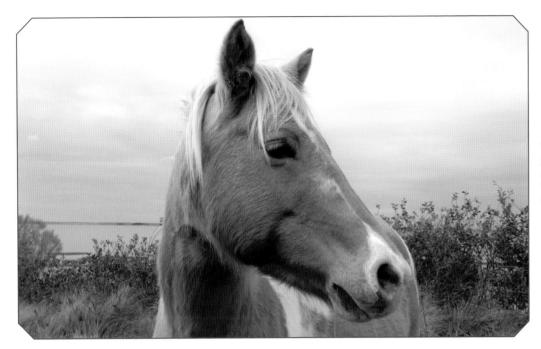

WHISPER *is a favorite among many, perhaps because she resembles the famous storybook star, Misty of Chincoteague. Here, Whisper grazes by a water hole.*

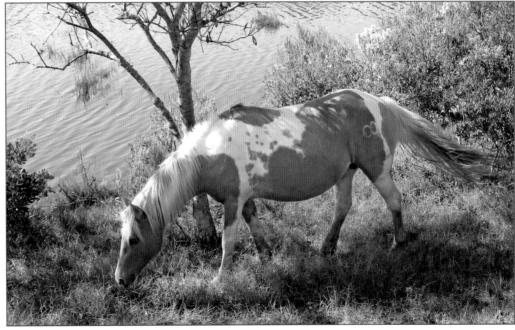

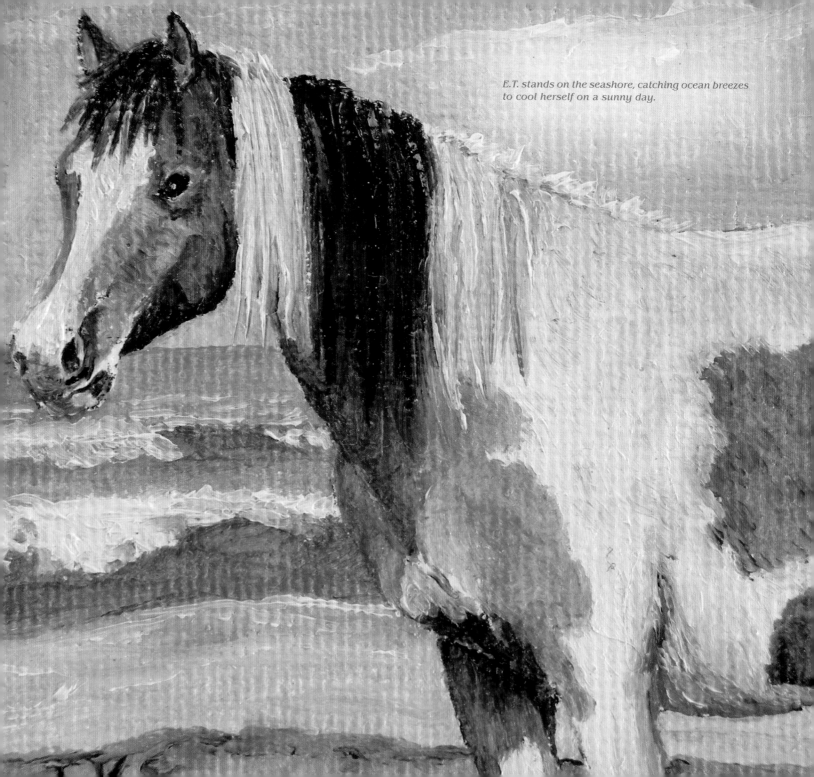

E.T. stands on the seashore, catching ocean breezes to cool herself on a sunny day.

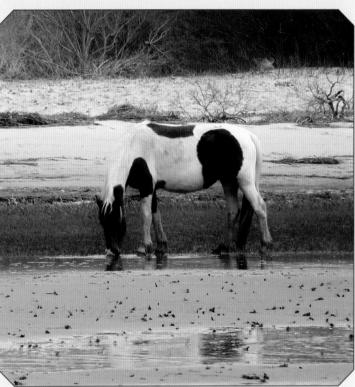

*This painting shows the mare, **GOT MILK**. She was named for the white nose that looks like she dipped it in a glass of milk.*

*This shows the other side of **GOT MILK**.*

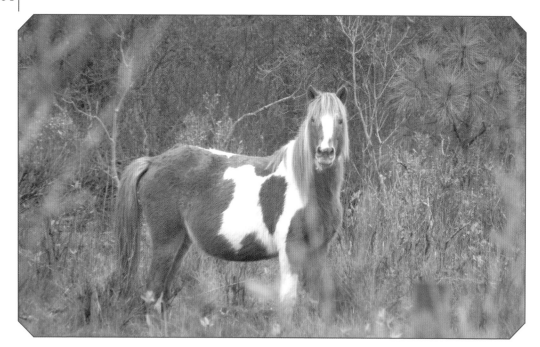

This mare is called **GIRAFFE** by the Buyback Babes because her markings resemble the spots on a giraffe.

A greater egret watches **SHYANNE** (nicknamed Half and Half) as she sucks up water at the water hole.

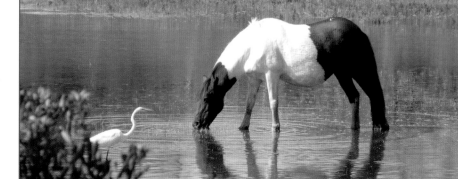

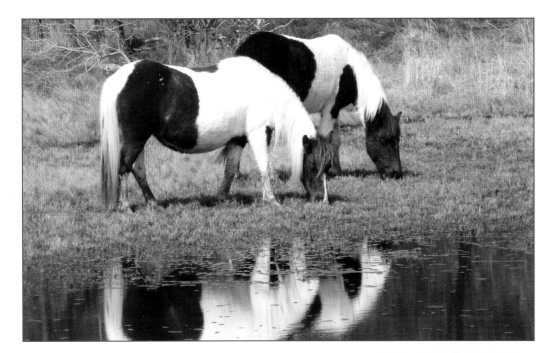

In the foreground is **SALT AND PEPPER** (nicknamed Buffalo Girl). She grazes beside **ANGEL WINGS**.

The pinto mare, **STEVENSON'S DAKOTA SKY**.

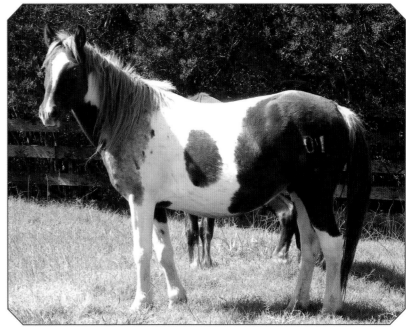

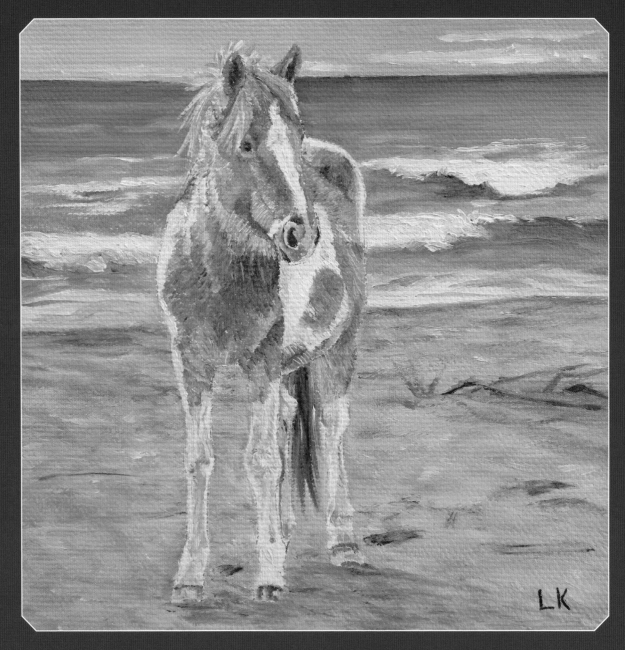

This 2006 foal is **COURTNEY'S ISLAND DOVE** *(nicknamed Dove).*

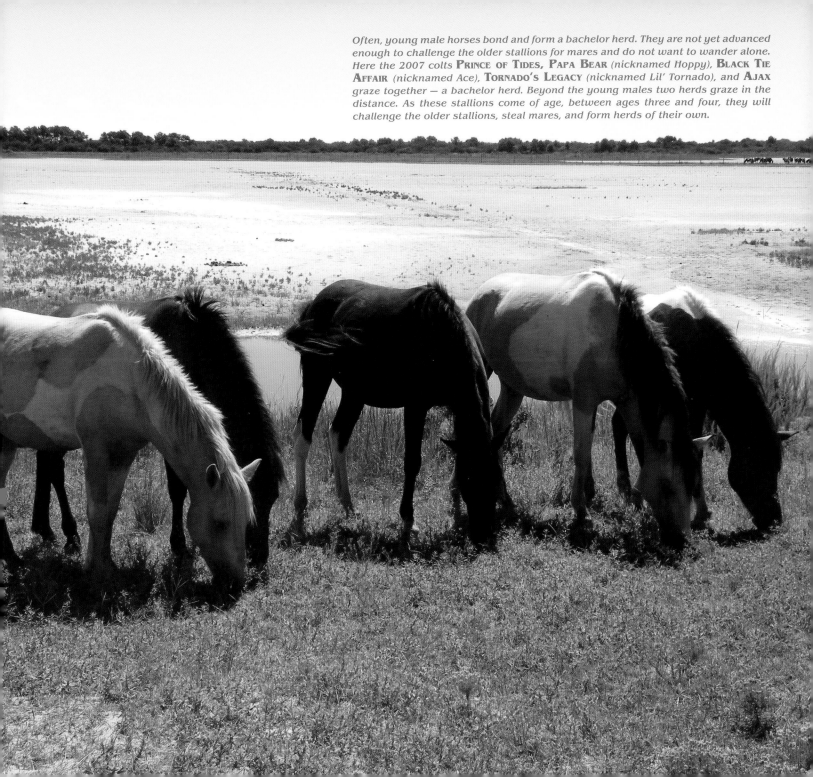

Often, young male horses bond and form a bachelor herd. They are not yet advanced enough to challenge the older stallions for mares and do not want to wander alone. Here the 2007 colts PRINCE OF TIDES, PAPA BEAR (nicknamed Hoppy), BLACK TIE AFFAIR (nicknamed Ace), TORNADO'S LEGACY (nicknamed Lil' Tornado), and AJAX graze together — a bachelor herd. Beyond the young males two herds graze in the distance. As these stallions come of age, between ages three and four, they will challenge the older stallions, steal mares, and form herds of their own.

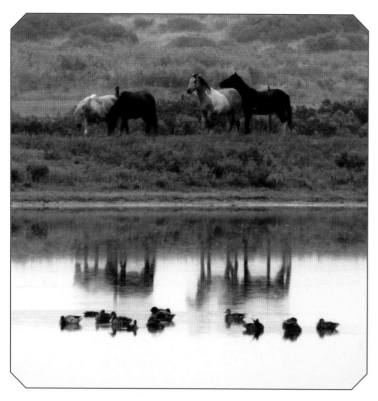

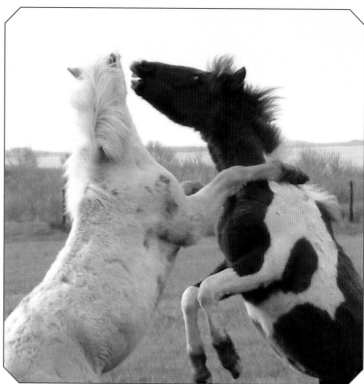

Four colts, left to right: **TORNADO'S PRINCE OF TIDES** *(nicknamed Prince),* **PAPA BEAR** *(nicknamed Hoppy),* **TORNADO'S LEGACY** *(nicknamed Lil' Tornado), and* **BLACK TIE AFFAIR** *(nicknamed Ace) travel together. Ducklings float on the water before them.*

A yearling named **CHIEF GOLDEN EAGLE** *(nicknamed Chief) stands on his hind legs in mock battle with* **ARCHER'S GAMBIT** *(nicknamed Puzzle).*

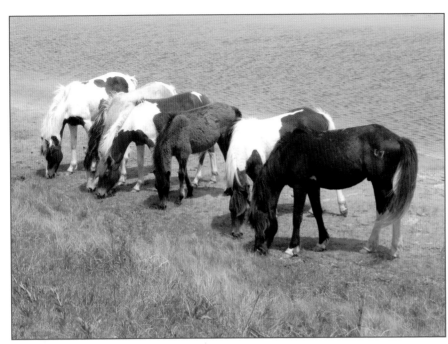

Left to right: **BEACH BABY, MOLLY'S ROSEBUD, CATWALK CHAOS, BABE'S BUCKEYE** *(a foal the Chincoteague Fire Company donated to a Feather Fund child),* **SWIRL***, and* **BLACK TIE AFFAIR** *graze side-by-side.*

SURFER DUDE *(with his head up and nose extended) and his mares in 2011.*

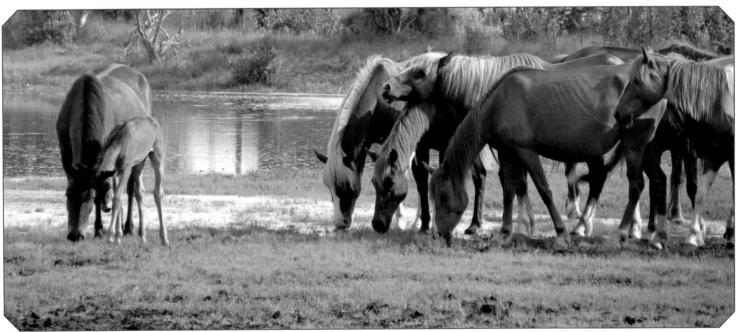

The chestnut pinto in the front is **AMERICA'S SWEETHEART**. *She grazes with two bay mares and two 2011 foals.*

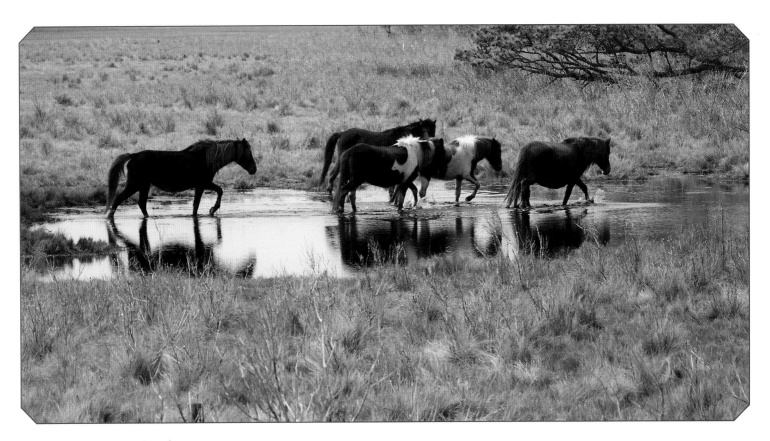

A herd of five ponies on the refuge.

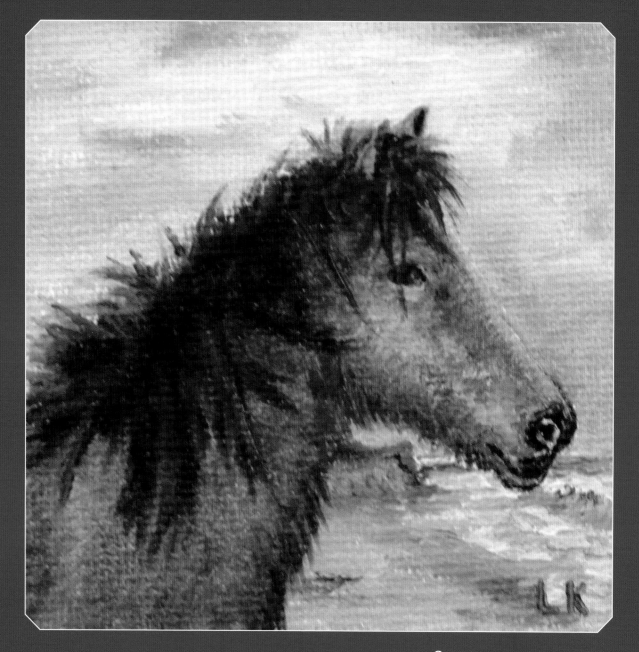

OPPOSITE:
Two mares stop to drink from a vernal pool. The bay mare in front is named **PAPPY'S PONY.**

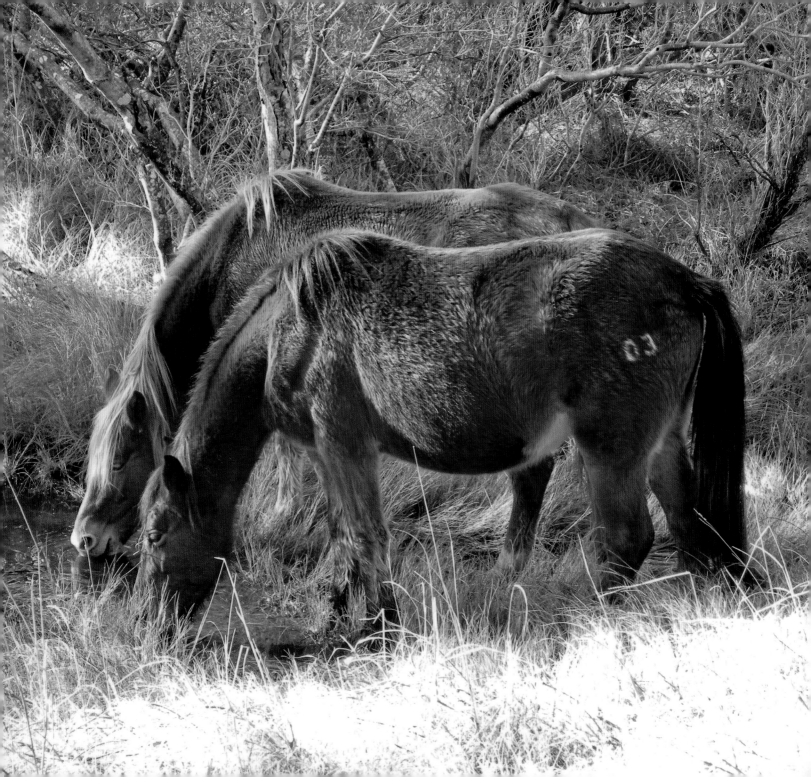

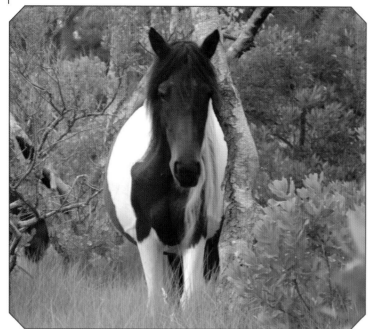

For this mare named **QUEENIE**, a slender tree makes a fine scratching post. The first foal to hit the shore during the wild pony swim is dubbed King or Queen Neptune and is raffled off. She was the Queen Neptune foal in 2003. The little girl who won her in the raffle was unable to keep her. She asked the fire department if she could donate her back to the herd and they agreed. (Queenie's dam is Seaside Wanderer, nicknamed Bird Poop.)

This mare is **SLASH OF WHITE**, but some call her True Love because at one time she was Leonard Stud's favorite mare.

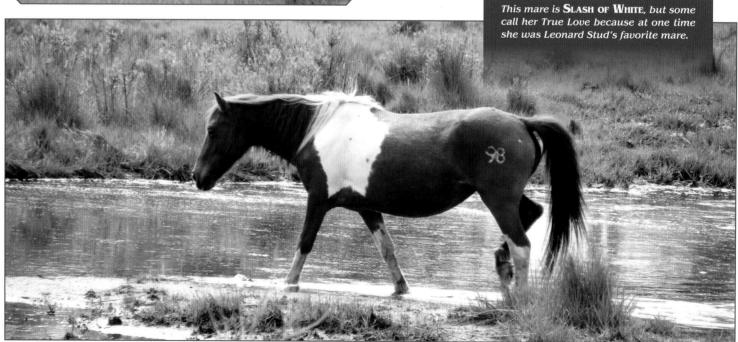

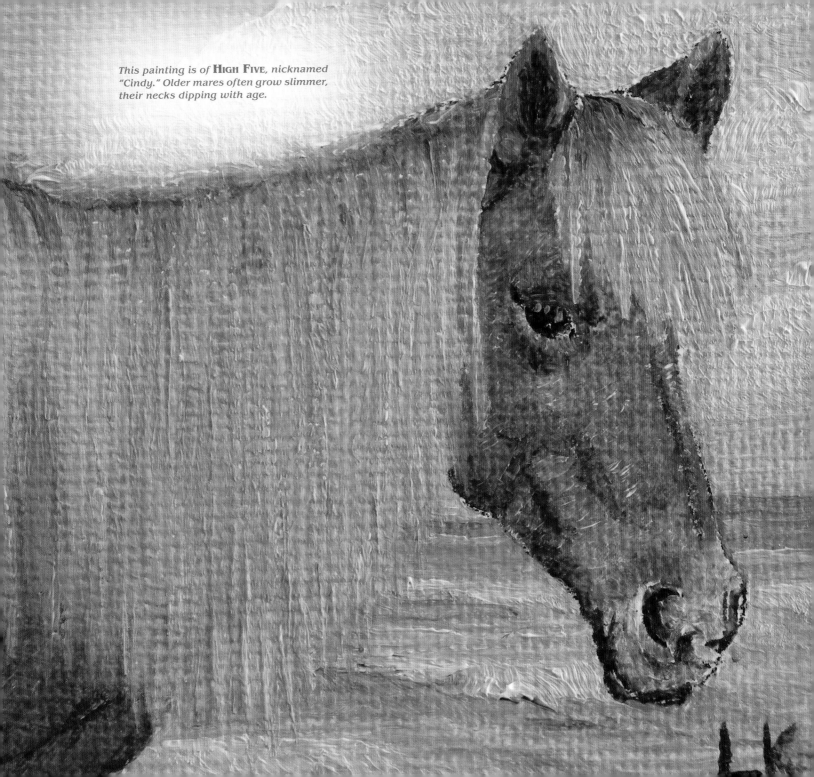

*This painting is of **HIGH FIVE**, nicknamed "Cindy." Older mares often grow slimmer, their necks dipping with age.*

Autumn brings fuzzy coats in preparation for winter.

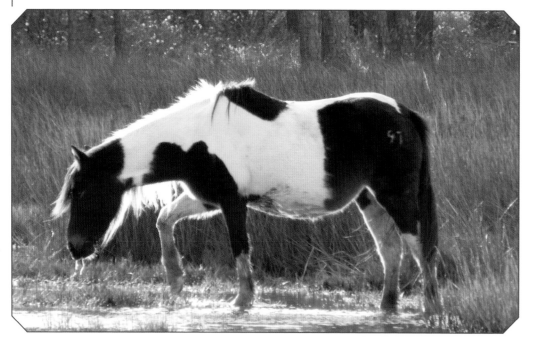

A fuzzy **DREAM CATCHER** picks her way through the water. As winter approaches, bird life on the island increases. More ducks and geese migrate onto the refuge and the ponies encounter shoveler ducks, pintails, widgeons, rudy ducks, canvasbacks, mallards, teals, redheads, ring necked ducks, and bluebills. Mergansers, buffleheads, golden eyes, and other diving ducks show up in the nearby bay — a sign of cold weather to come. Off the coast, rafts of sea ducks and small groups of oldsquaw ducks forage along the shoals over the winter.

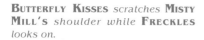

BUTTERFLY KISSES scratches **MISTY MILL'S** shoulder while **FRECKLES** looks on.

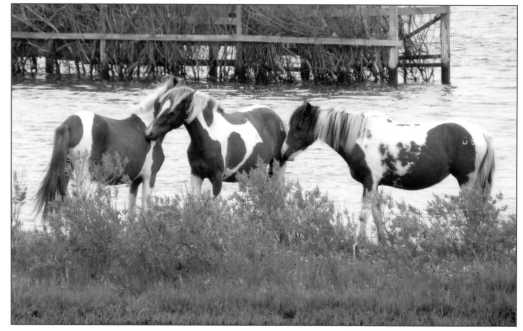

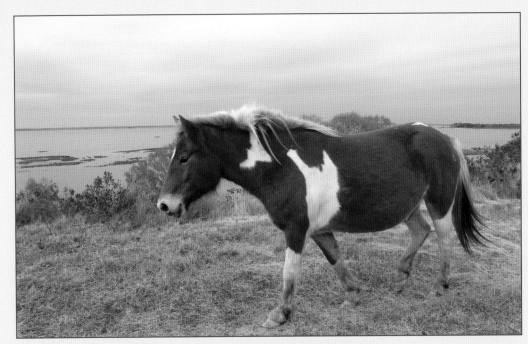

KIMBAL'S RAINBOW DELIGHT

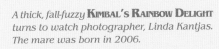

*A thick, fall-fuzzy **KIMBAL'S RAINBOW DELIGHT** turns to watch photographer, Linda Kantjas. The mare was born in 2006.*

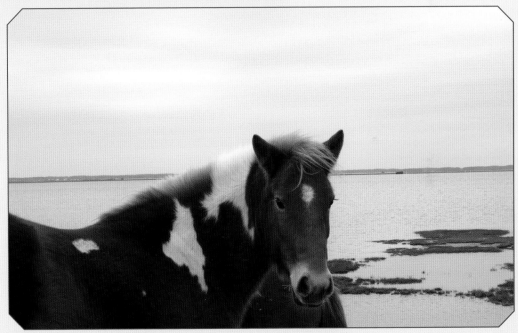

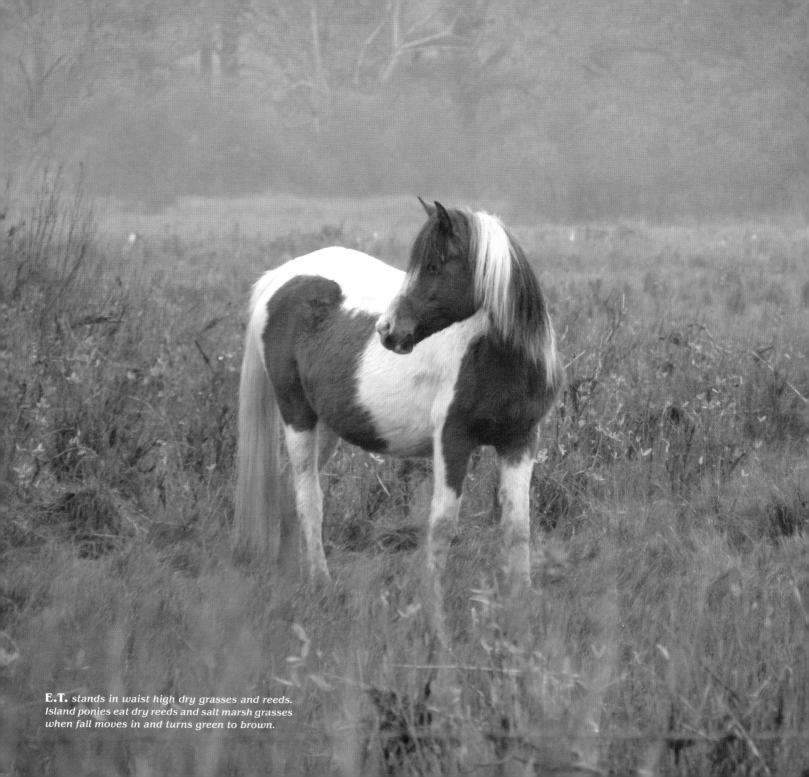

E.T. *stands in waist high dry grasses and reeds. Island ponies eat dry reeds and salt marsh grasses when fall moves in and turns green to brown.*

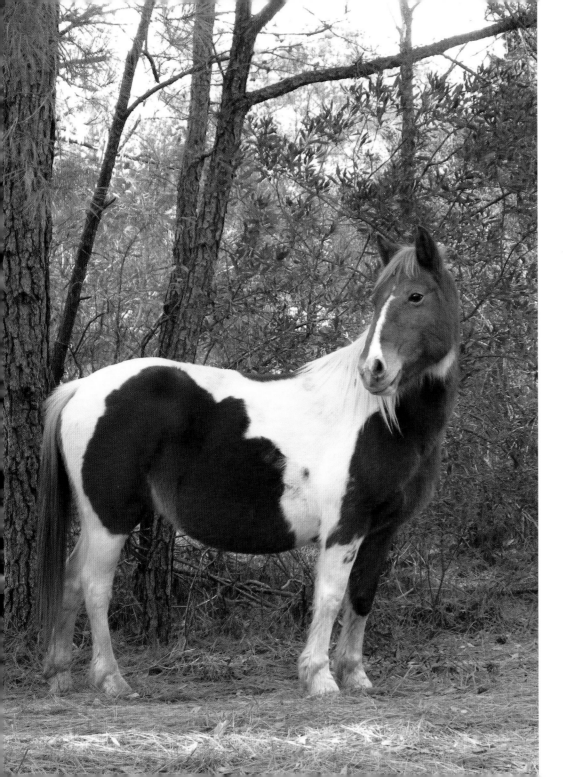

Chincoteague Ponies find refuge from sun and ravaging winds in quiet loblolly pine forests where thick pine needle beds cushion their feet and trees insulate them from bad weather. Here's **RAMBLIN' RUBY**.

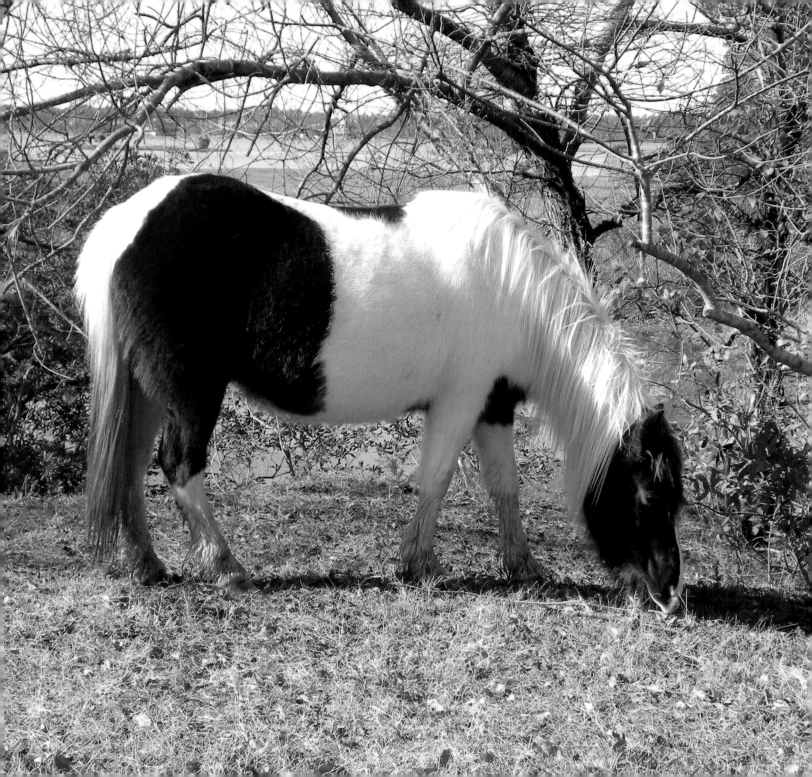

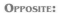

OPPOSITE:

SALT AND PEPPER *(nicknamed Buffalo Girl) grazes on dry autumn grass.*

DREAM DANCER *has a curly coat, not a common feature of Chincoteague Ponies.*

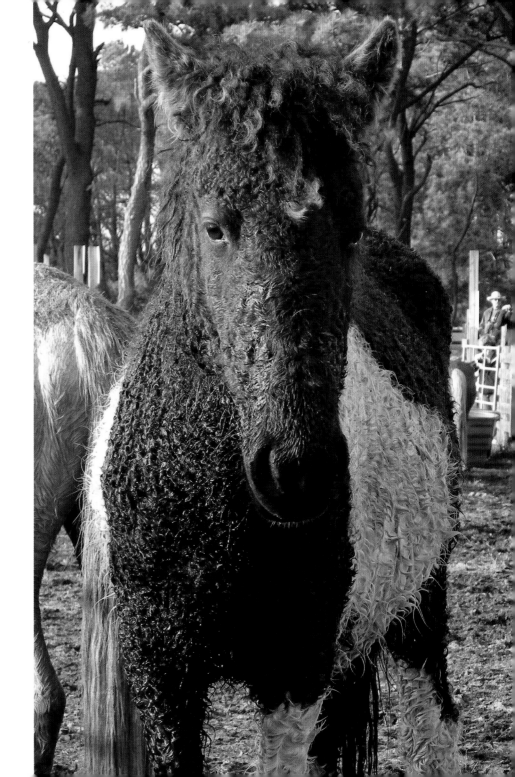

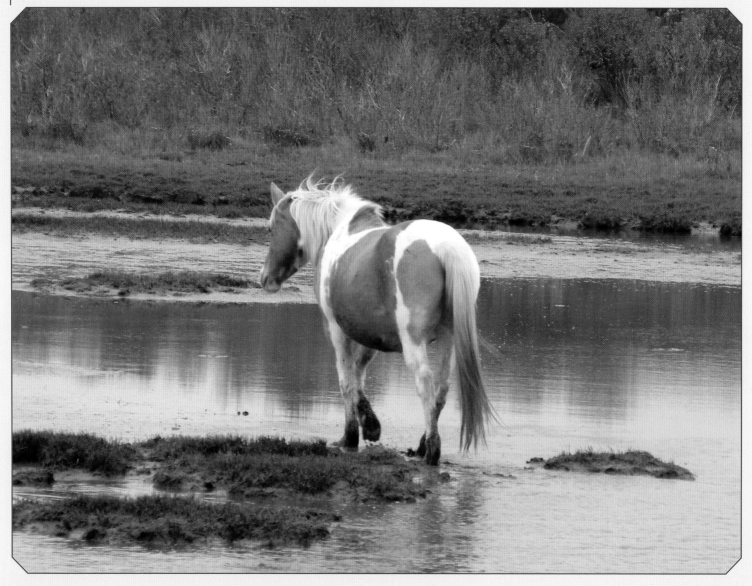

WHISPER *picks her way through mud and water.*

OPPOSITE:
WHISPER *leads while* **SALT AND PEPPER** *follows.*

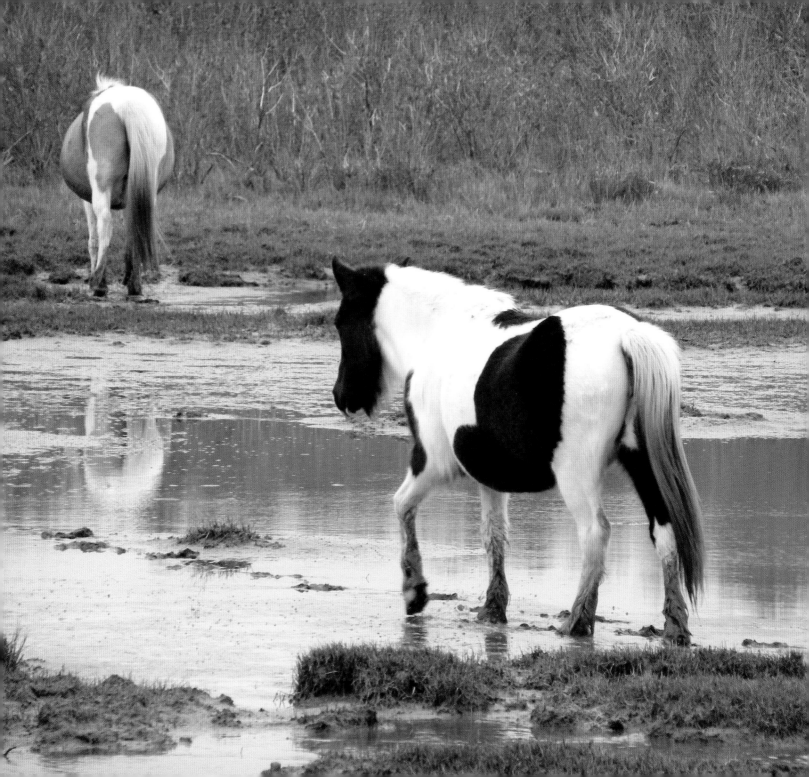

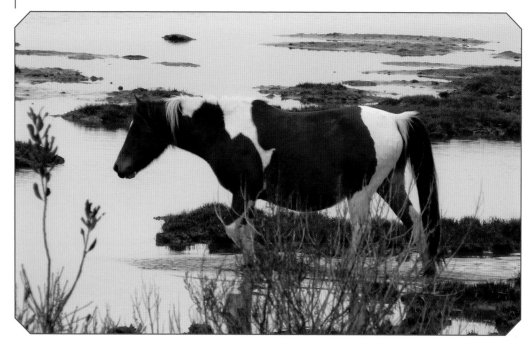

The mare **DESTINY'S FEATHERING SPIRIT** treks through the marsh. Joanne Rome and her mom, Ginny have four buybacks on the island — one stallion and three mares. Destiny is one of their mares; she was purchased in the fall of 2002 to replace a mare named Ginny's Dream Catcher they purchased in 1997. The mare had disappeared over the winter. Rome said she added the word "Feathering" because of the Feather Fund. "The story (of the Feather Fund) was touching. I believe the spirit of Dream Catcher brought Destiny to us and the spirit of Carollynn (of the Feather Fund) will look down and keep an eye on Destiny for us," she said.

OPPOSITE:
This mare is **MIRACLE'S NATURAL BEAUTY**.

The mare **TULETA'S STAR** is a 2002 buyback.

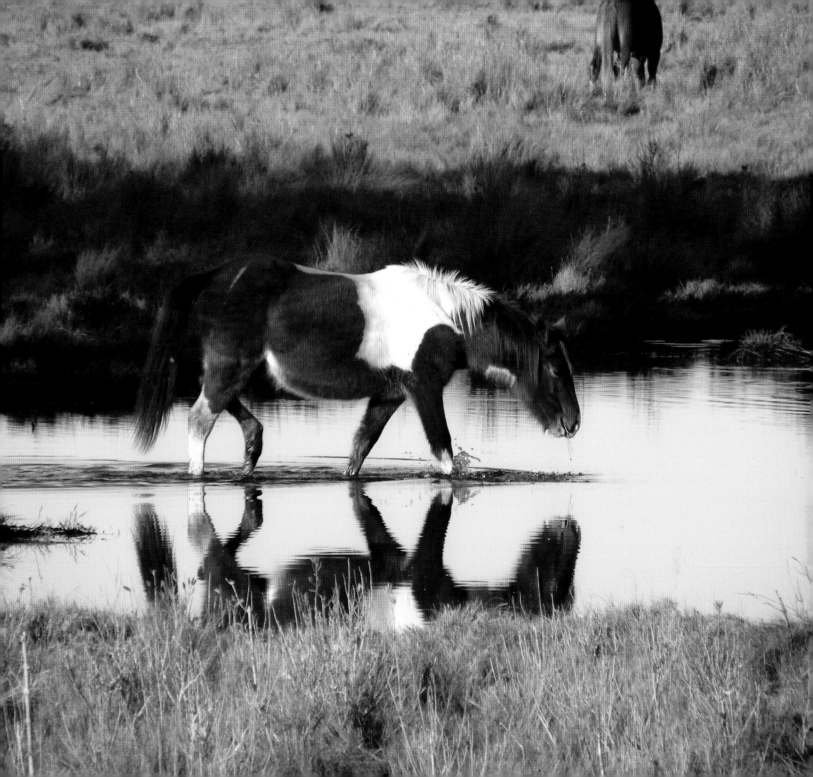

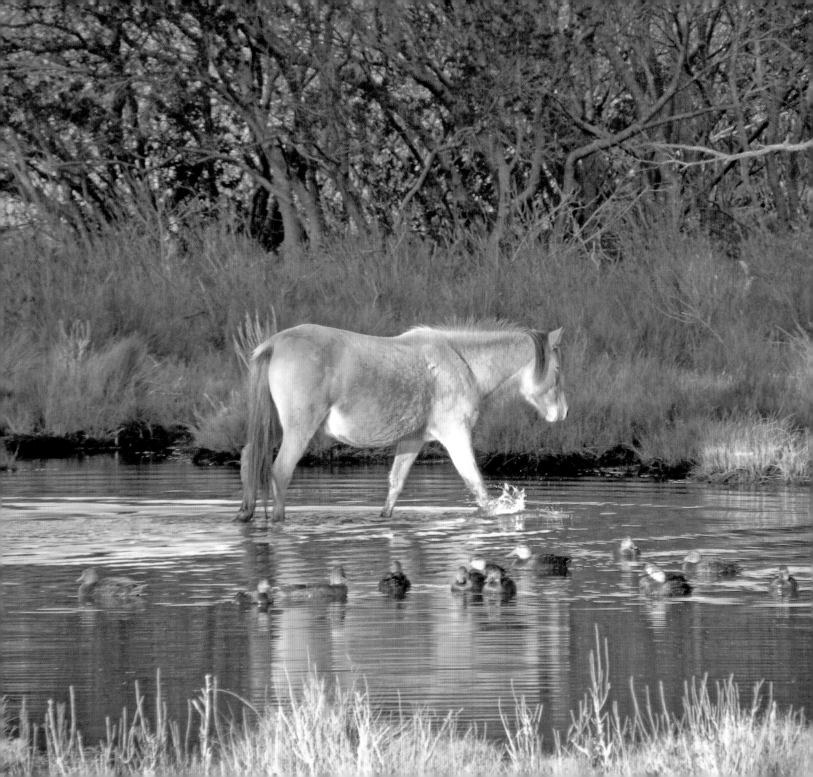

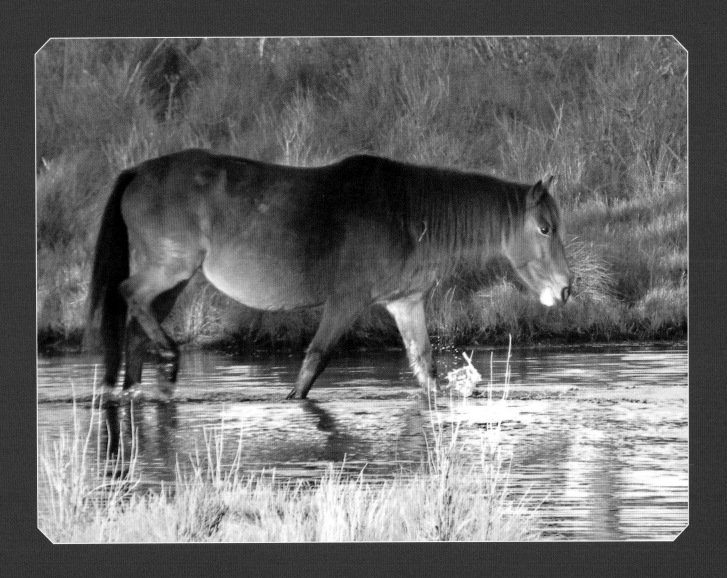

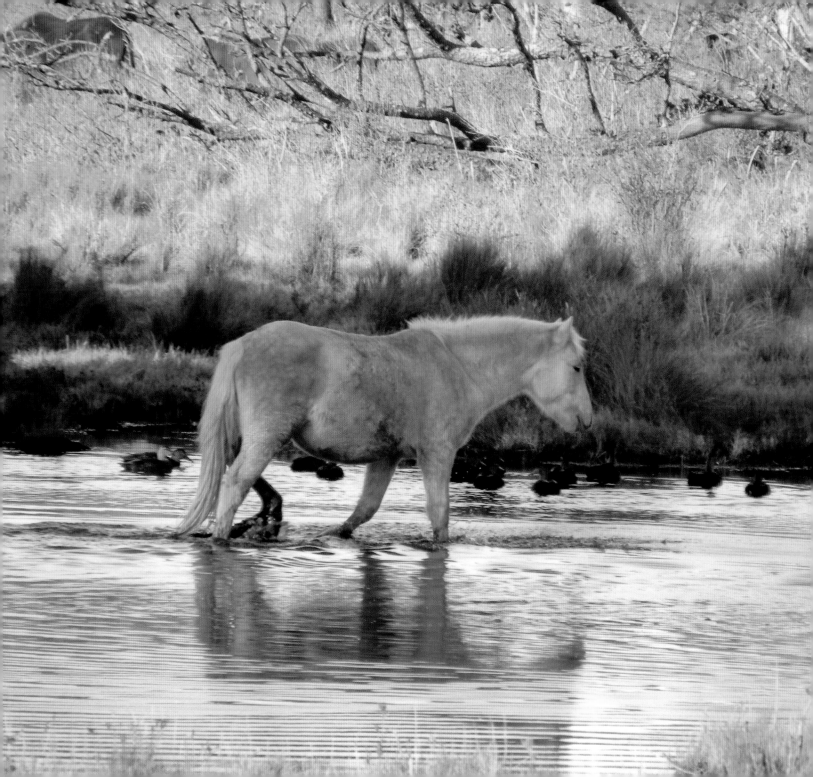

OPPOSITE:

CHIEF GOLDEN EAGLE *crosses the water on a crisp fall day.*

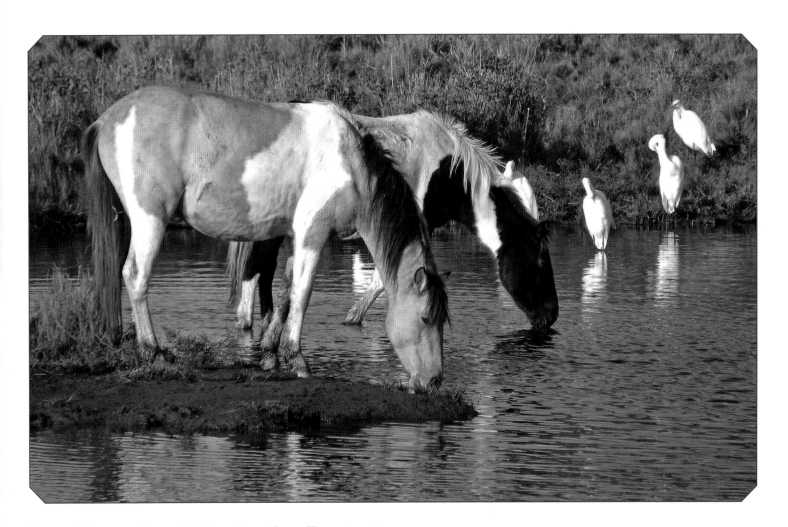

TORNADO'S LEGACY *(nicknamed Lil' Tornado) and* **ANGEL WINGS** *share the water hole with a flock of greater egrets.*

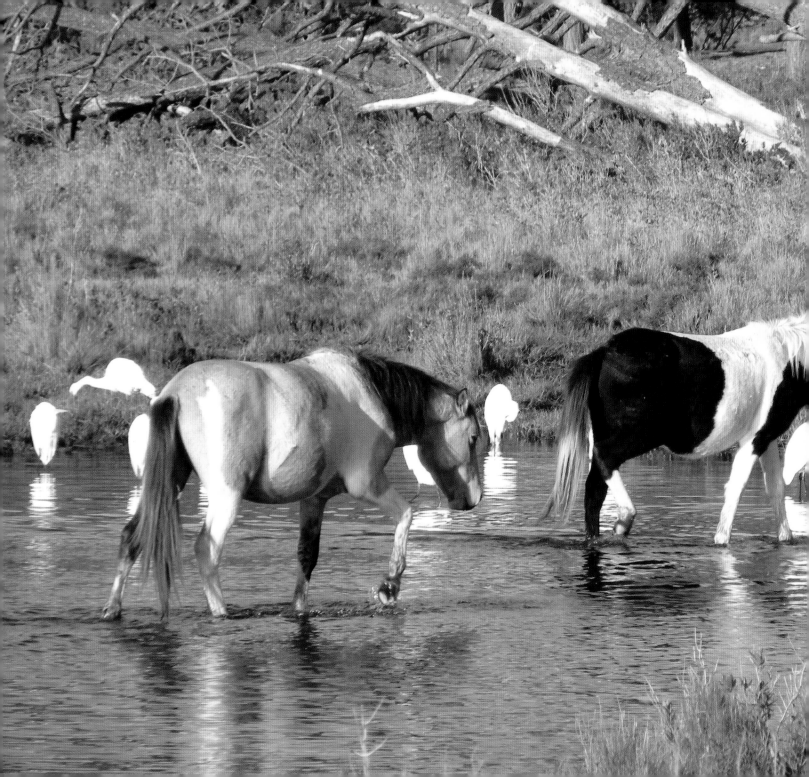

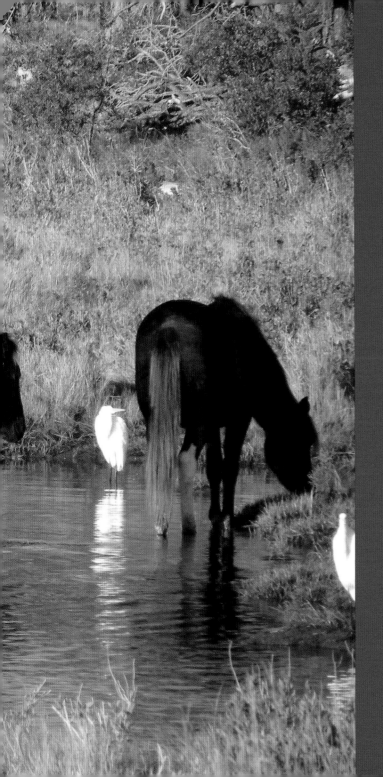

Moving past a flock of egrets are **BLACK TIE AFFAIR** *(also called Ace),* **ANGEL WINGS,** *and* **TORNADO'S LEGACY** *(Lil' Tornado) in the rear.*

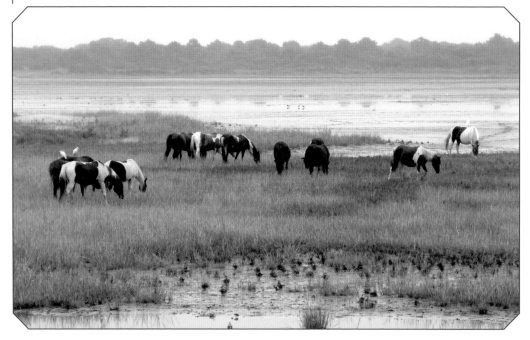

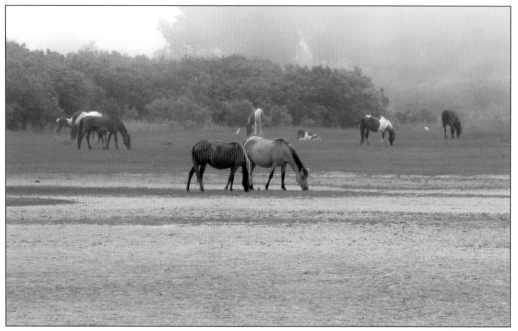

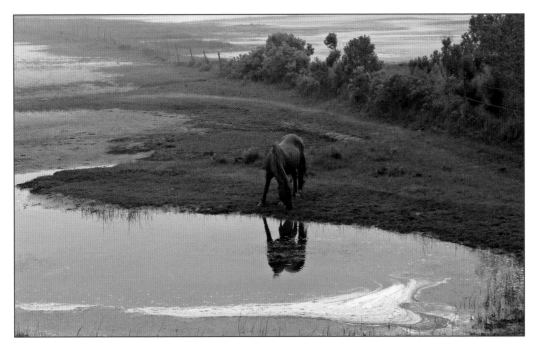

A lone pony grazes before catching up with his herd. Note the fences constructed to keep the ponies out of areas designated by the Refuge to protect the environment of other species.

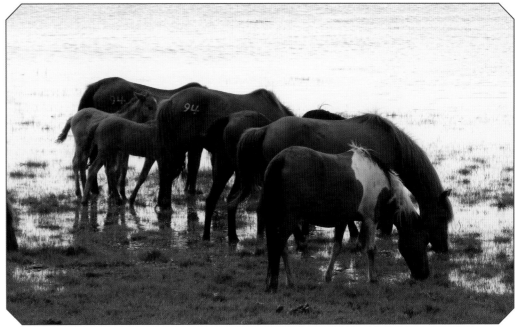

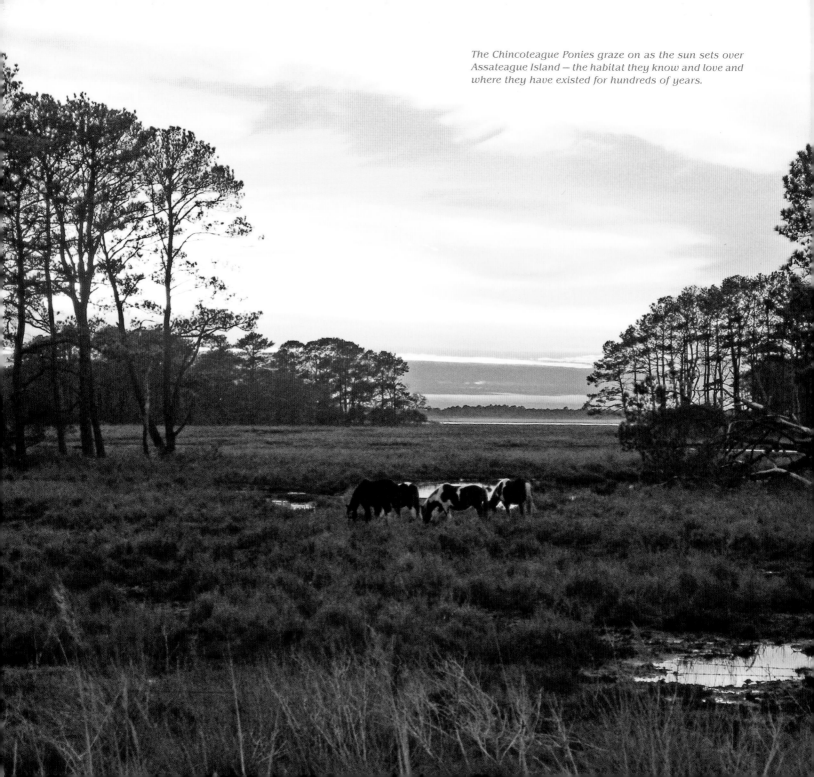

The Chincoteague Ponies graze on as the sun sets over Assateague Island — the habitat they know and love and where they have existed for hundreds of years.

Afterword

As you turn the final page of this book — one that identifies the island's Chincoteague pony herds and their stories — we hope you have gained a lasting appreciation and deeper insight into these ponies, their habitat, and the relationships they have with the creatures that share their island home.

Resources

BEEBE RANCH
3062 Ridge Road, Chincoteague, VA 23336
Phone: 757-336-6520
Email: beeberanch@aol.com

CHINCOTEAGUE CHAMBER OF COMMERCE
6733 Maddox Blvd., Chincoteague, VA 23336
Phone: 757-336-6161
Website: www.chincoteaguechamber.com

CHINCOTEAGUE VOLUNTEER FIRE COMPANY
4028 Main Street, Chincoteague, VA 23336
Phone: 757-336-3138
Website: http://cvfc3.com

CHINCOTEAGUE PONY DISCUSSION LIST
*(Discussion and information site for
 Chincoteague Pony owners and lovers)*
Website: http://pets.groups.yahoo.com/group/
 chincoteaguepony

CHINCOTEAGUE NATIONAL WILDLIFE REFUGE
8231 Beach Road Chincoteague, VA 23336
Phone: 757-336-6122
Email: fw5rw_cnwr@fws.gov
Website: www.fws.gov/northeast/chinco

CHINCOTEAGUE NATURAL HISTORY ASSOCIATION
 8231 Beach Road
Chincoteague VA 23336
Phone: 757-336-3696

CHINCOTEAGUE PONY CENTRE
Chicken City Road, Chincoteague VA 23336
Phone: 757-334-2776 or 757-336-6313
Email: ponycntr@intercom.net
Website: www.chincoteague.com/ponycentre

CHINCOTEAGUE PONY FARM
6500 Leonard Lane, Chincoteague, VA 23336
Phone: 757-336-1778
Email: Chincoteagueponyfarm@yahoo.com
Website: www.chincoteagueponyfarm.com

FEATHER FUND
The Community Foundation of Carroll County
255 Clifton Blvd., Westminster, MD 21158
Phone: 410-876-5505
Website: www.featherfund.org

MISTY OF CHINCOTEAGUE ASSOCIATION
17183 Point Lookout Rd.
Lexington Park, MD 20653
Phone: 301-737-4230

WILD PONY TALES AND INFO
www.wildponytales.info

THE CHINCOTEAGUE PONIES OF ASSATEAGUE, VA
www.wildislandponies.net

THE COLORFUL CHINCOTEAGUE
www.colorfulchincoteague.mistysheaven.com